IMAGES

of America

BRATTLEBORO

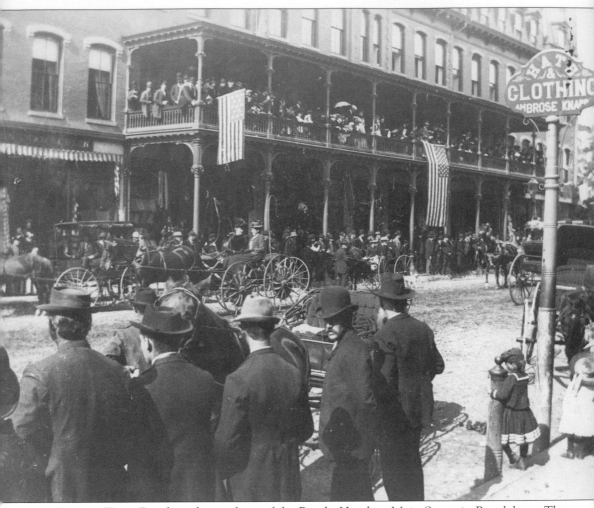

PARADE TIME. People gather in front of the Brooks Hotel on Main Street in Brattleboro. The hotel was built in the early 1870s to replace many of the buildings that were destroyed by a major fire in 1869. The two-story open porch was much used for events such as this one.

IMAGES
of America

BRATTLEBORO

The Brattleboro Historical Society

ARCADIA

Copyright © 2000 by The Brattleboro Historical Society.
ISBN 0-7385-0474-2

First printed in 2000.

Published by Arcadia Publishing,
an imprint of Tempus Publishing, Inc.
2 Cumberland Street
Charleston, SC 29401

Printed in Great Britain.

Library of Congress Catalog Card Number: 00-106493

For all general information contact Arcadia Publishing at:
Telephone 843-853-2070
Fax 843-853-0044
E-Mail sales@arcadiapublishing.com

For customer service and orders:
Toll-Free 1-888-313-2665

Visit us on the internet at http://www.arcadiapublishing.com

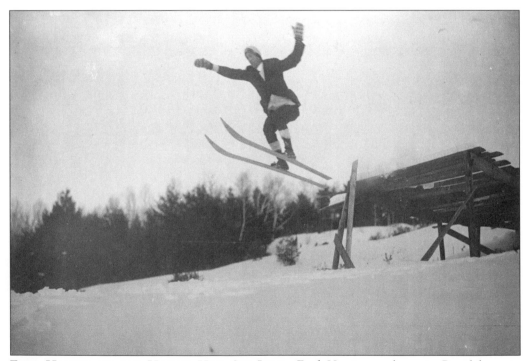

FRED HARRIS AT THE HARRIS HILL SKI JUMP. Fred Harris was born in Brattleboro in 1887. He was responsible for introducing ski jumping to Brattleboro. The ski jump continues to attract major ski jumping competitions to Brattleboro as part of modern winter sports in Vermont.

CONTENTS

ACKNOWLEDGMENTS

Recognition is given to Brattleboro's early photographers, whose work made this book possible. Special thanks has to be given to Mary Rogers Cabot (1856–1932) for having the foresight and the determination to write and publish the *Annals of Brattleboro*, from which much of the information for this book is gleaned. Other sources include *Before Our Time*, the Brattleboro Retreat's *150 Years of Caring*, Brattleboro Town Directories, the *Vermont Phoenix*, and the *Brattleboro Reformer*. Thanks to Richard and Natalie Wellman, Richard Mitchell, and Richard Michelman for their passion in accumulating vast collections of material, and to Jeff Barry for continuing his quest of local history. Thanks to trustees, members, and friends of the Brattleboro Historical Society for their contribution to the research and writing of this book. Not to be omitted are three extraordinary, tenacious individuals who coordinated and edited the entire project: Hazel Anderson, Mary Lou Buchanan, and Wayne Carhart.

—Brattleboro Historical Society

INTRODUCTION

Brattleboro's ability to weather the storms of economic swings warrants some thought. Development started in Brattleboro and in the community to its west called the West Village (West Brattleboro) primarily because the Whetstone Brook flowed through most of this area. Its path traveled a major drop in elevation and therefore provided an excellent source of waterpower for mill operation. Not only was there a good source of waterpower, but the Connecticut river provided a way to move the finished product to southern markets in the 19th century. Such economic growth nurtured the arrival of new ethnic groups, as well as an active cultural community. Prominent writers and lecturers visited with regularity, and many made their homes in Brattleboro.

A town hall was constructed in 1885, and an auditorium was added in 1895, providing a venue for entertainers and lecturers. Henry Ward Beecher, Mark Twain, Horace Greeley, and Oliver Wendell Holmes spoke there. Entertainers such as Will Rogers, John Philip Sousa, and Alfred Lunt also performed at this site. Rudyard Kipling made his home just a few miles north of Brattleboro's downtown. A popular retreat in the 1850s was Dr. Robert Wesselhoeft's Water Cure, frequented by the well-to-do who traveled to Brattleboro to take advantage of his treatment.

The construction of the interstate highway in the 1960s, the decline of the Vermont dairy industry, the shift of the mill industry to the south, the development of the ski and tourist industry, people buying second homes in Vermont, and the arrival of the communes during the 1970s all played a more recent role in shaping what Brattleboro is today. These developments strengthened Brattleboro by bringing in a diverse population, one that is accepting of newcomers, and thereby creating the strong work force that is part of Brattleboro's contemporary economic base.

Many dot-com businesses are sprouting up. There are over 60 published authors living in the Brattleboro area. Farming has declined, but while much of the pasture land has grown back to forest, many of the farmsteads are in better condition now than when first purchased by newcomers and the farmers were leaving the dairy business. Mill manufacturing no longer plays a major role in the economics of Brattleboro; however, new businesses have moved to the area and contribute to the community as much as the mills did a century ago.

After 50 years of strip development and urban sprawl, people are looking for a sense of belonging—a Main Street where folks can shop, meet their neighbor, and feel a part of their community. Brattleboro's civic groups are taking advantage of the national trend to stabilize

and revitalize main streets. Imaginative reuse of buildings is under way.

Brattleboro's Main Street buildings are mostly brick construction built in the latter part of the 1800s. They are solid structures, reflecting the architecture of the time. Because this was a period when the river was seen more as an economic resource, with its potential beauty unrecognized and recreational use discouraged, all of the buildings constructed on the east side of Main Street had their backs to the river in an attempt to block the view—and why not? The river was an open sewer and coal-powered locomotives traveled along its banks. Now, with a greater awareness of the need to preserve our natural resources and cleaner diesel-powered locomotives, a new interest in opening river views has developed in Brattleboro. A recently vacated building is being modified to create an enclosed river garden so that people can enjoy the view of the Connecticut River in all four seasons.

Brattleboro had many studio photographers during the early days of photography and was host to many printing and publishing businesses. This is the reason why so much of Brattleboro's history has been captured by photography and why the Brattleboro Historical Society is able to present it to you in this book.

Not all topics are covered. Lack of adequate documentation for certain events and space restrictions are the main reasons for most omissions.

One
EVERYDAY LIFE
AND HAVING FUN

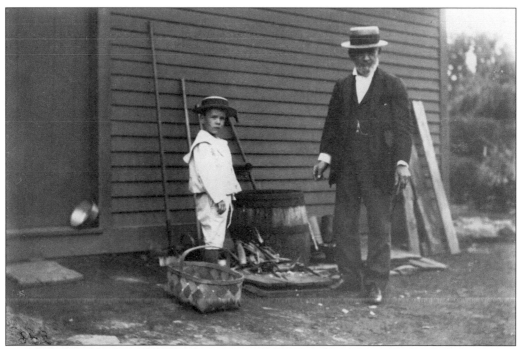

HUSKING CORN. Cabot Holbrook and his grandfather Norman F. Cabot prepare to husk some corn outside the Cabot residence at the corner of Tyler and Terrace Street in this *c.* 1900 photograph.

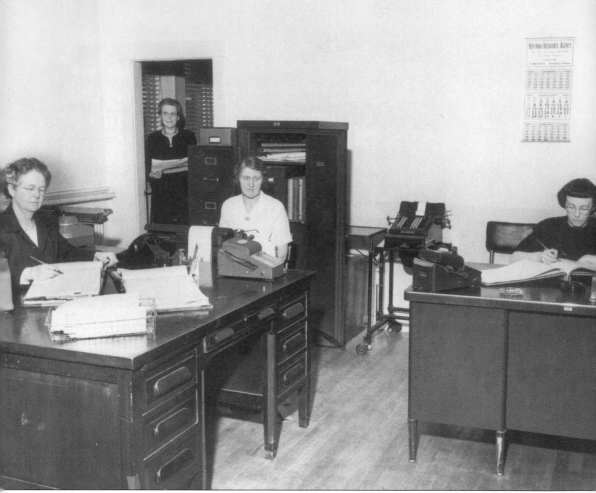

TOWN EMPLOYEES AT THE TREASURER'S OFFICE. Until the building was demolished in 1953, workers in the town treasurer's office carried out their duties in the town hall erected in 1885. Katherine Christmas is shown at the right carefully entering handwritten information into town ledgers, c. 1951. When the town offices moved to the renovated former high school, the property was developed for commercial use. Following a major fire that destroyed the F.W. Woolworth store in November 1972 and the later closing of the W.T. Grant store, the Main Street Gallery and the Key Bank building were constructed on the site.

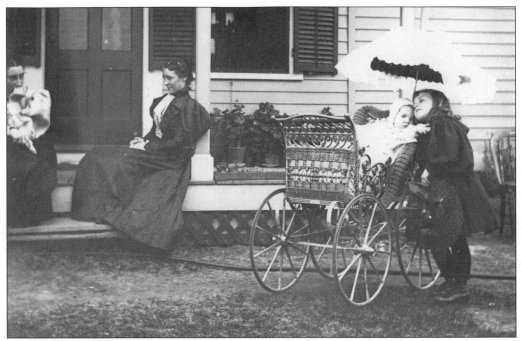

CATALOG SALES. A warm weather outing is enjoyed by all parties in this *c.* 1900 photograph by William Vinton. A similar wicker carriage appeared in the Sears, Roebuck catalog in 1900.

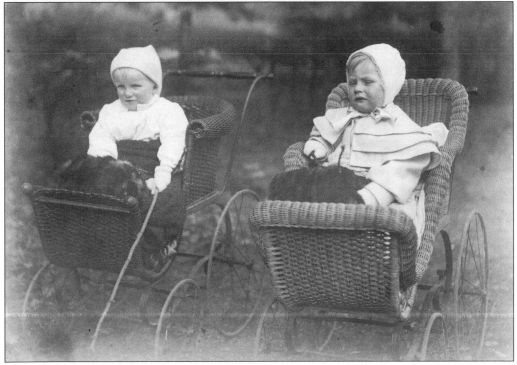

CHILDREN IN CARRIAGES. Howard C. Rice Jr. and Lyman Adams are bundled up on an excursion in their wicker carriages in the fall of 1906. Fur robes kept their feet warm. Collecting sticks apparently kept them occupied.

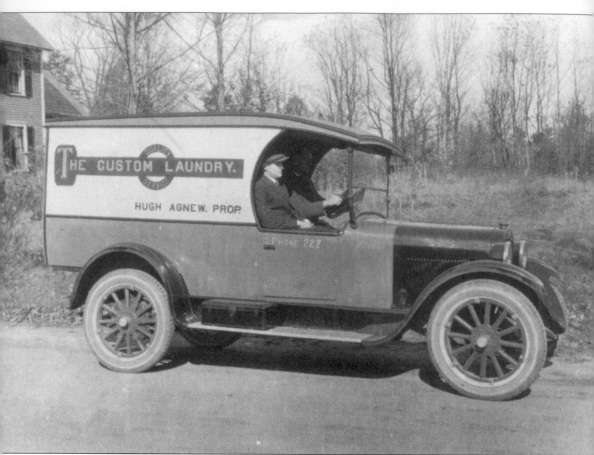

CUSTOM LAUNDRY. In November 1921, Hugh Agnew, proprietor of the Brattleboro Custom Laundry, engaged Pellet and Skinner to construct a new two-story building on Church Street. Although delivery vehicles have changed since the early 1920s model, a large modern Custom Laundry van travels its routes and has originated from the same location for almost 80 years.

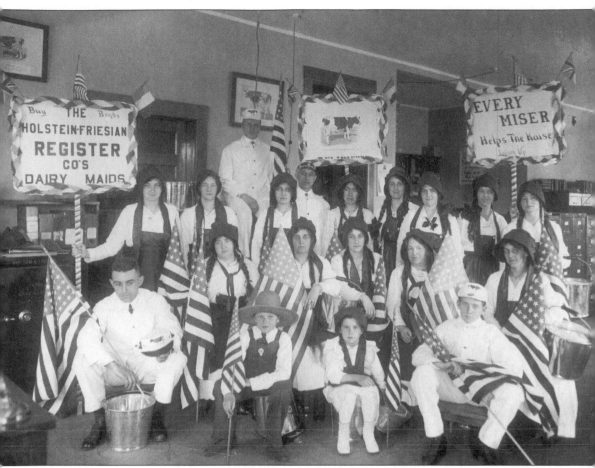

THE HOLSTEIN-FRIESIAN ASSOCIATION. Holstein-Friesian employees and families display their patriotism by encouraging the purchase of bonds to support the war effort for World War I, "the war to end all wars," in this *c.* 1917 photograph.

FRESH AIR CHILDREN. A group of Fresh Air Children from New York City pose with their hostesses in front of the railroad station as they arrive for visits in 1929. The Fresh Air Program continues to operate today.

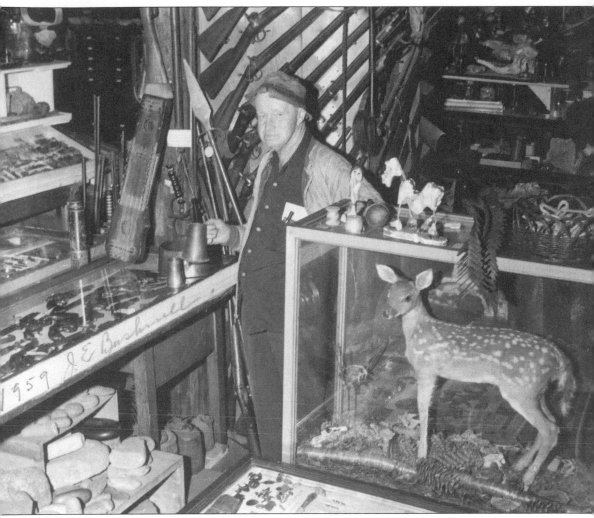

THE BUSHNELL MUSEUM. Jason Bushnell, pictured in this 1959 photograph, augmented his grocery store business with his homegrown museum. He also held the position of the Town of Brattleboro health officer.

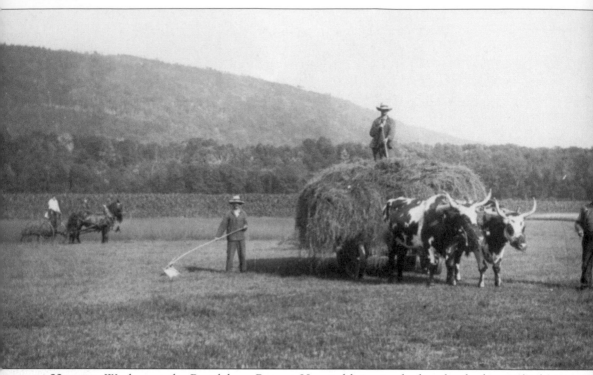

HAYING. Workers at the Brattleboro Retreat Hospital bring in the hay for the hospital's farm with the help of a team of oxen. The image was photographed on September 13, 1908.

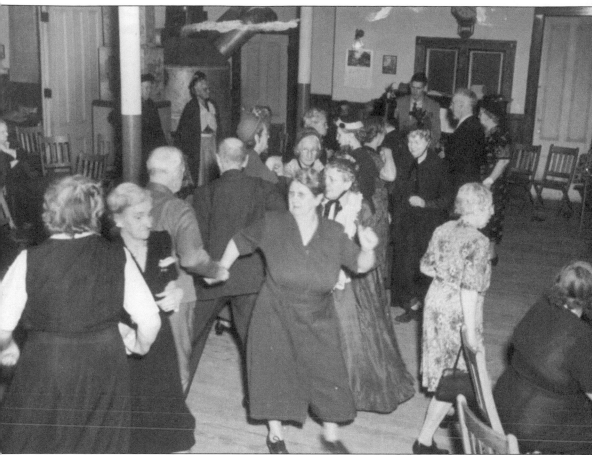

SQUARE DANCING. This scene, taken in 1952, is filled with the aura of small-town entertainment in years gone by. It shows the Golden Age Club in full swing at the Grange Hall on lower Canal Street. These elders had fun square dancing to recorded music. Refreshments, available during intermission, helped to keep them moving on the dance floor long into the evening.

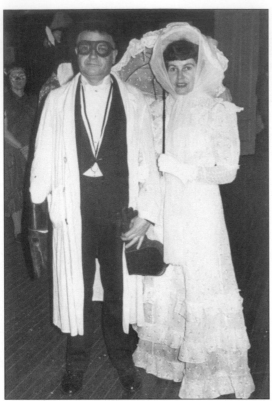

THE KIWANIS COSTUME BALL. Do not let their serious tone fool you—these folks are really having a ball! The Brattleboro Kiwanis Club raised money for various charities by putting on dances. This costume ball occurred in the 1950s.

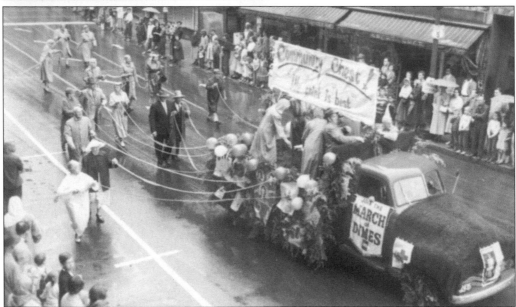

MARCHING THROUGH TOWN. "Brattleboro loves a parade," proclaimed one lifelong resident to a newcomer in the 1990s. That statement is as true today as it was back in 1955, when this photograph was taken on Main Street. Perhaps it is because parades were, and still are, fun for spectators and marchers alike. Graduations, conventions, or a new fire truck were all reasons for parading up and down the town's main thoroughfare.

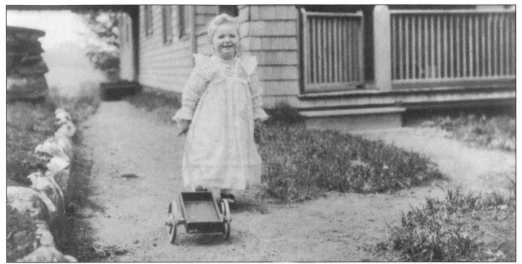

KIPLING'S DAUGHTER AT PLAY. Josephine Kipling, daughter of renowned author Rudyard Kipling, plays happily with a little two-wheeled cart. The elder Kipling spent a number of years in the Brattleboro area, penning his famous stories. Perhaps his tales of faraway places inspired his daughter to seek adventures of her own, much closer to home. Could her cart have held a favored doll, just delivered to the exotic surroundings of the family's side door? Toys in the 1890s were simple and obviously not motorized but, as is apparent in this photograph, still provided joy and entertainment to youngsters. Sadly, this little girl died in New York shortly after this photograph was taken.

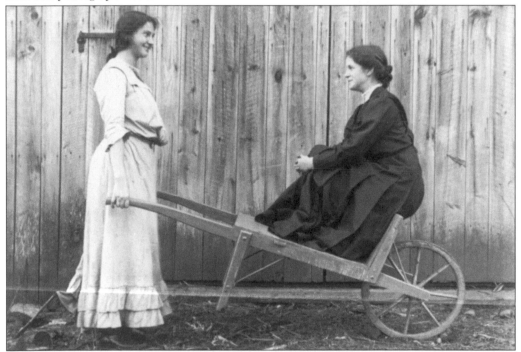

HOMEGROWN FUN. In 1906, entertainment was homegrown. A strong friend and a wheelbarrow meant an afternoon of bumping around the barn. That's how Grace Burnett and Mabel Barrows made their own brand of simple fun.

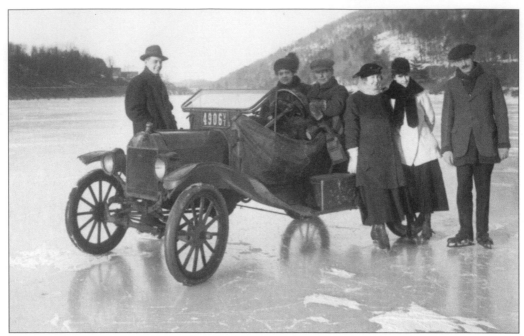

How Thick Is That Ice? An adventuresome couple in an old Ford runabout joins a group of skaters on the Connecticut River near the Hinsdale Bridge. Quick stops were easier for the skaters than for the car. Note the thick fur blanket and stout gloves on the car's occupants. A winter's drive in a convertible was no picnic!

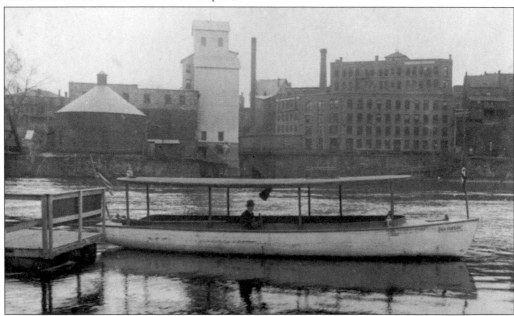

A Bigelow Boat. This Bigelow boat was a passenger launch that carried people from Island Park in the Connecticut River to Vernon and Hinsdale. The round trip cost 50¢. After the flood of 1920 took out the bridge from Brattleboro to Island Park and Hinsdale, two of these launches were kept very busy ferrying people across the river. Their usefulness waned with the construction of new steel bridges.

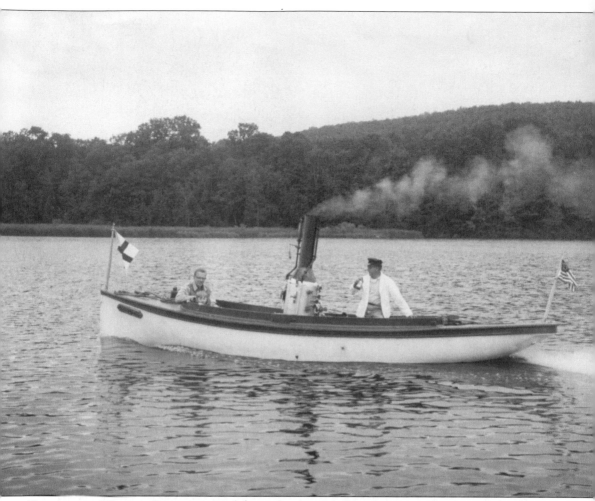

FUN ON THE WATER. Cruising up and down the river is a fine way to spend a summer day, but it is even more rewarding to do it in a boat that you have built yourself. Dick Mitchell of Hinsdale, New Hampshire, built this steam-powered launch and enjoyed taking friends up and down the Connecticut River.

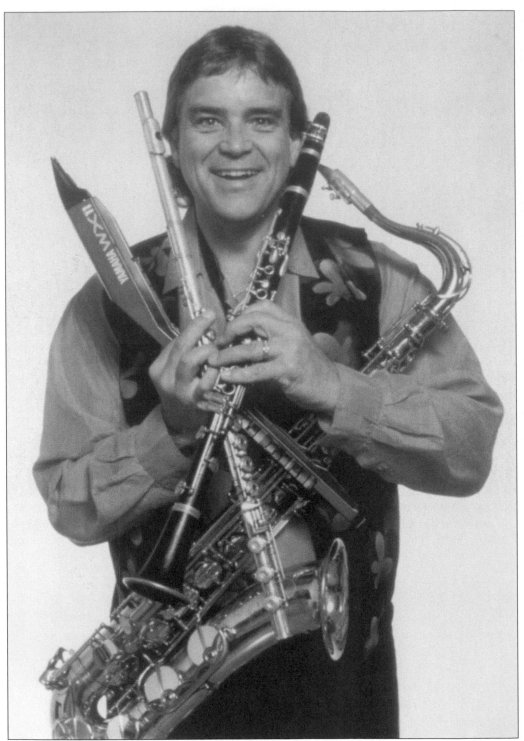

A MUSICAL PICNIC. Bill Shontz can play anything on any instrument. With his friend Gary Rosen, the team of Rosen and Shontz entertained crowds in the Brattleboro area during the 1980s. They played, they sang, and they kept the kids laughing with their Teddy Bear Picnics.

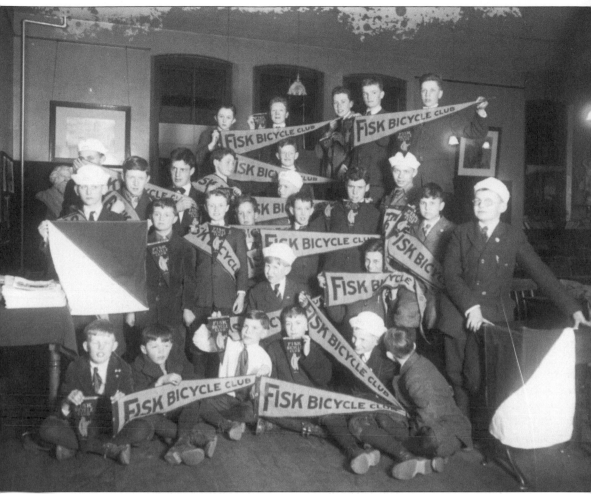

EASY RIDERS. Looking a bit like a Boy Scout troop, the Fisk Bicycle Club claimed more than two dozen members, yet not a single bicycle can be seen! Some members sported sailor hats; nearly all wore ties.

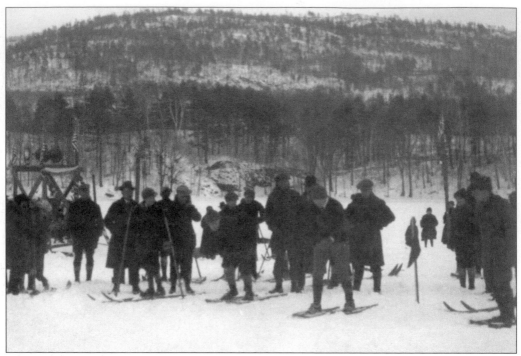

WINTER ON THE MEADOWS. Winter on the Retreat Meadows brought out skis and snowshoes. Before the snow fell, there was usually a week or two of good ice-skating. After that, the equipment shown here was much more effective at getting one across the frozen water. No fancy boots or bindings, no special ski jackets, and no ski lift yet.

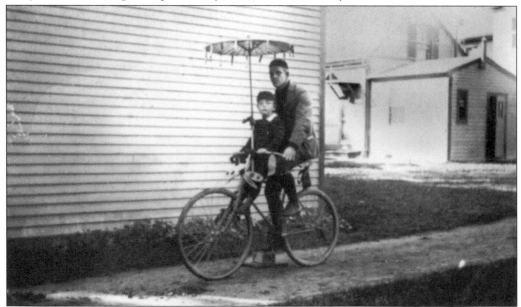

A BICYCLE WITH ALL THE ACCESSORIES. Most Brattleboro residents know Fred Harris for his exploits on skis. Here, however, Charlie Harris is taking his young son Fred for a spin on a bicycle. This is a "new" style bicycle, with wheels much smaller than those popular throughout the 19th century. Harris's bicycle was decorated with a parasol and a wing-flapping paper moth.

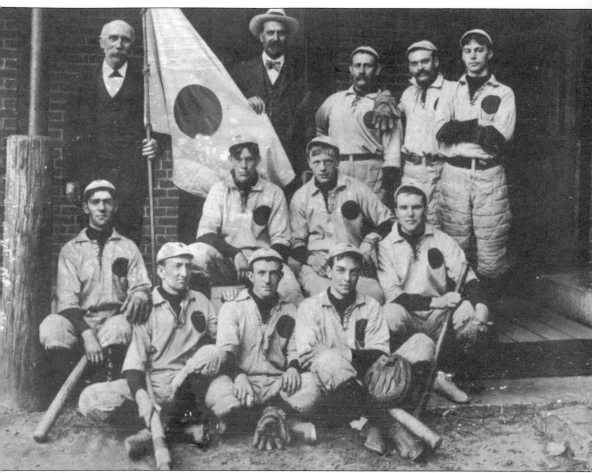

PLAY BALL! This 1902 baseball team, playing on Island Park for Dunham Brothers, was among the first of nearly 20 years of home teams. A spacious grandstand provided comfortable seating for spectators at the Island Park ball field. All this came to an end when the big flood of 1927 practically wiped out the island. Note the red circle Ball Band boots trademark on the uniforms.

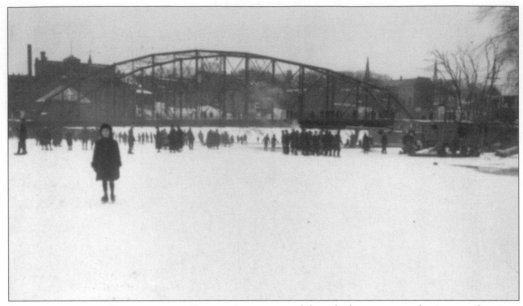

SKATING ON THE CONNECTICUT RIVER. It seems as if the whole town was skating on the river in this scene, photographed in 1917. Many a cold December provided ice and skating opportunities before the snow came.

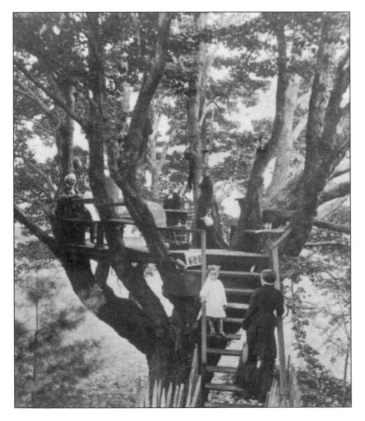

A TREE ON THE WOOD FARM. Kids of all ages (including a senior citizen) enjoyed this tree house at the Wood Farm on South Main Street. Benches were plentiful and sturdy, and certainly the youngsters climbed higher when the parents were not looking.

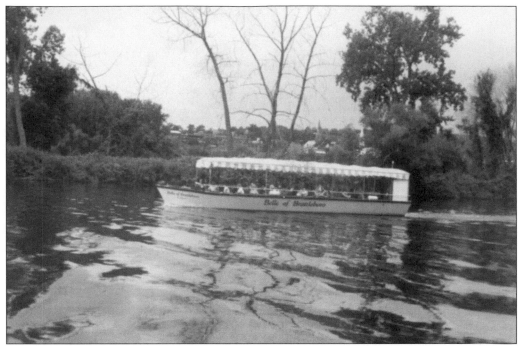

THE BELLE OF BRATTLEBORO. By 1985, the confluence of the West and Connecticut Rivers became home waters for the *Belle of Brattleboro*. This pleasure boat still carries about 40 people while traveling leisurely up and down the Connecticut. Refreshments are available, wedding parties are held on board, and side curtains make even rainy days a pleasure. This photograph shows the *Belle* heading down the "Little River," that portion of the Connecticut that separates the island from New Hampshire.

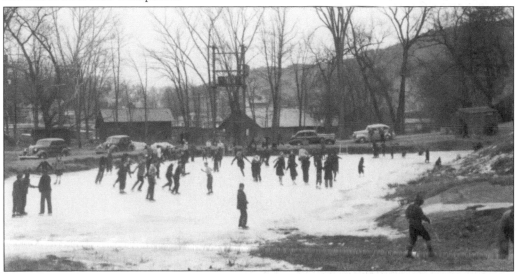

SKATING ON WHITNEY POND. The river and the Retreat Meadows were not the only places in Brattleboro for ice-skating. This pond on Frost Street was originally used as a source of ice for old-fashioned iceboxes. When electric refrigerators became common, skaters took over the pond in the winter months. At times, the ice, chewed up by the blades of many skaters, was flooded to create a better surface. The year 1946 had a good winter for skating.

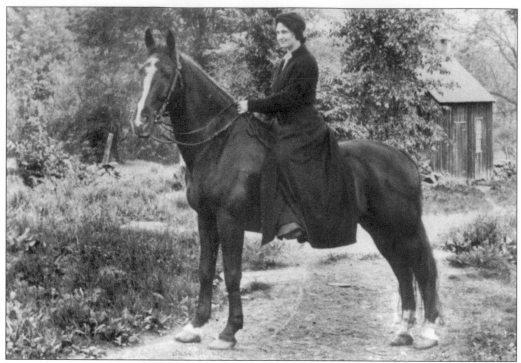

DR. GRACE BURNETT. Dr. Grace Burnett was the first woman doctor in Brattleboro, practicing in town from 1914 to the late 1950s. She loved horses and kept several in the barn behind her house on Western Avenue. The buildings on her property were removed when Interstate 91 was built.

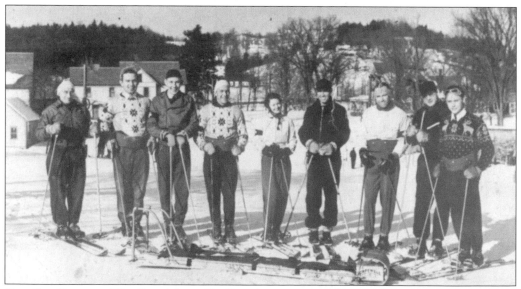

THE SKI PATROL. The Brattleboro Ski Patrol was organized in the late 1930s, just as skiing became a popular sport. Several ski tows had been established and, early on, the need for patrollers trained in first aid was realized. Many hours were spent learning to immobilize broken legs and to treat frostbite. This picture was taken at the Guilford Street tow, before the area was named Living Memorial Park. After a hiatus, the ski tow began operating again in 1999.

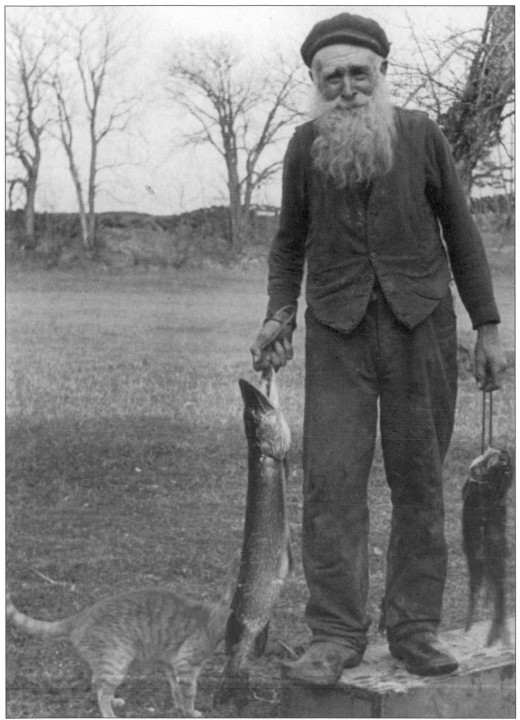

UNCLE WES. "Look out, Uncle Wes," the photographer must have called as he snapped the picture of the man proudly displaying the fish he caught in Sunset Lake. The cat in the lower left corner is extremely interested, but there should be more than enough fish for family and feline.

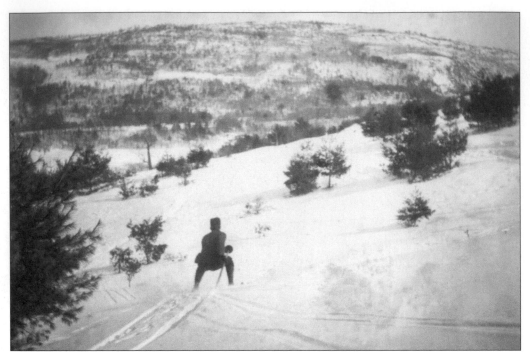

FRED HARRIS. Fred Harris founded the Dartmouth College Outing Club. Back in Brattleboro, he found a hill on Cedar Street that was perfect for downhill runs. Behind that hill was a steep slope for ski jumping. In 1922, he designed the takeoff, which has been improved over the years. National ski jumping competitions are still held at Harris Hill yearly. Note the use of only one ski pole in the above photographs.

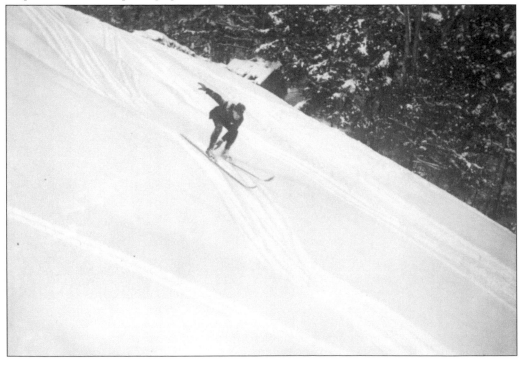

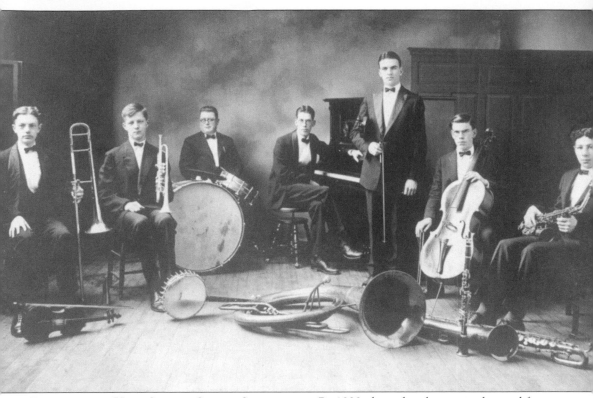

BRATTLEBORO HIGH SCHOOL SENIOR SERENADERS. By 1929, dance bands were in demand for weekend parties. These Brattleboro High School students produced a variety of tunes and tempos on their instruments.

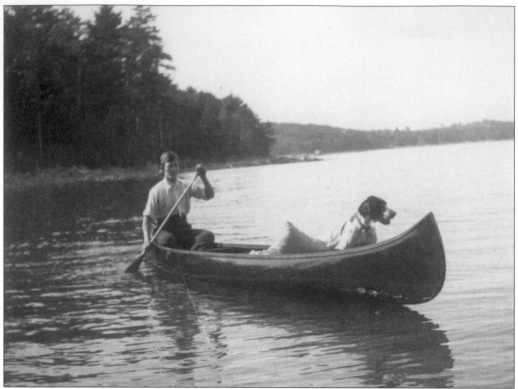

FRED HARRIS AT SPOFFORD LAKE. Among his many talents, Fred Harris both enjoyed and promoted boating on Spofford Lake, across the river from Brattleboro in Chesterfield, New Hampshire. Staying at one of the early cottages there, he would paddle with his dog on quiet days.

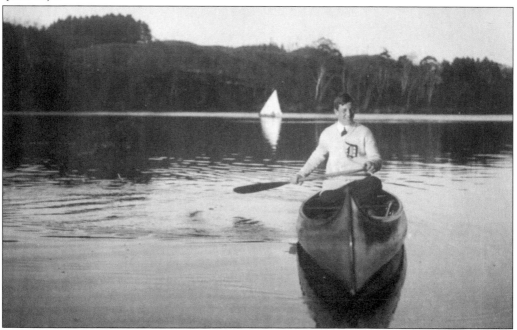

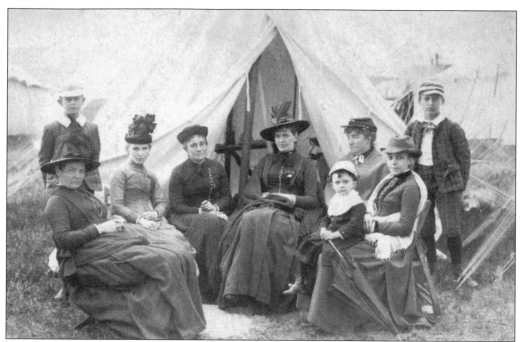

THE FULLER BATTERY. The Fuller Battery, a forerunner of the National Guard, was established by Gov. Levi Fuller in 1874. Fuller served as commander until 1889. When the troops marched around the Old Muster field on Ames Hill in Marlboro, wives and children looked on.

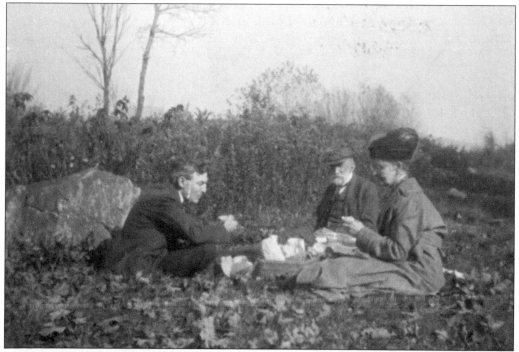

THE CLAPP FAMILY PICNIC. Fr. George W. Clapp came along on the picnic organized by son George H. Clapp and his wife. In 1910, picnics were served on china plates and lemonade was poured from Mason jars. This picnic happened on a warm autumn day.

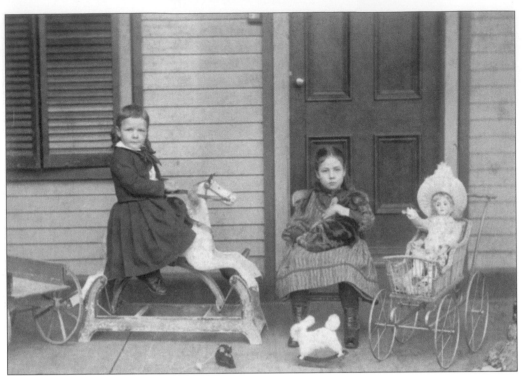

PLAYING ON THE PORCH. On a pleasant summer day in 1852, two children play happily on the front porch of a farmhouse. They have gathered dolls, rocking horses, and the cat, who seems anxious to leave. Dressed in their best, Ruth and her friend pause to allow a traveling photographer to take their portrait.

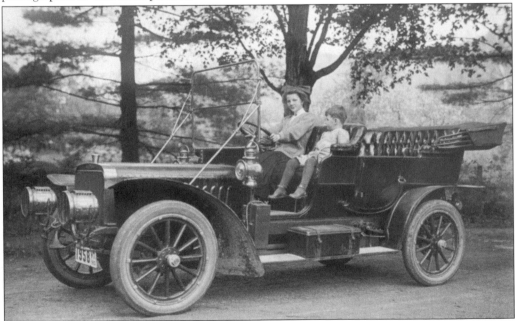

A DRIVE. What a thrill in 1910 to sit in the seat of the family car as your friend drives you both on an imaginary journey. Bring along the tools, just in case.

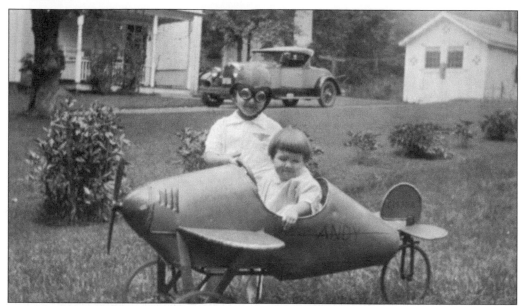

AN EARLY AVIATION ADVENTURE. Pilot Carl Anderson, with helmet and goggles, lets his sister Hazel Anderson check out his plane for an imaginary flight to the 1930 Valley Fair.

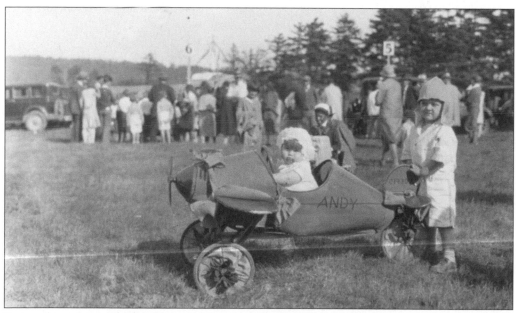

EARLY AVIATION. The brother-and-sister team land safely at Valley Fair, having changed their headgear and decorated the plane for a day at the fair.

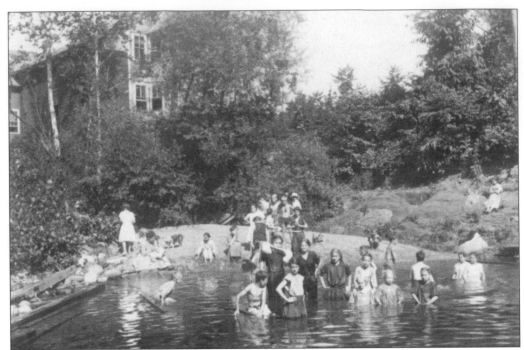

THE OLD SWIMMING HOLE. The old swimming hole at the foot of Crosby and Williams Streets, below the Carey House and opposite "Breakneck" Hill, is now obsolete. Formerly, there was a dam here on Whetstone Brook.

OUTDOOR AND INDOOR AMUSEMENTS. On a cold 1930s day, driver Ebba Augustson and passenger Rose Anderson prepare for a ride on a traverse made by Rose Anderson's father-in-law. The Swedish Lutheran Church is in the background. Using a very gentle force of air, Mary Lou Belczak, right, works on making the biggest bubble. She uses a bubble-making kit consisting of a blowpipe and a tube of a plastic gel, which is squeezed onto the end of the pipe. Like the Hulahoop, this kit was one of the amusements of the 1950s. Parents were often dismayed by it since the bubbles it created had a way of sticking to everything in the house.

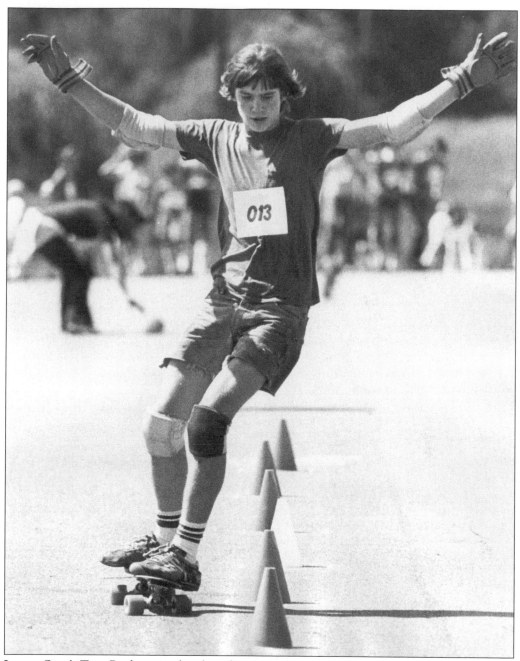

LOOK OUT! Tim Buchanan, skateboard virtuoso, competes at the 1977 Mammoth Mart Skateboard Competition. A group of Brattleboro Union High School skateboarders used a ramp in the foundation hole, caused by the Woolworth's fire, to practice some daring-do and other tricks, much to the delight of sidewalk fans.

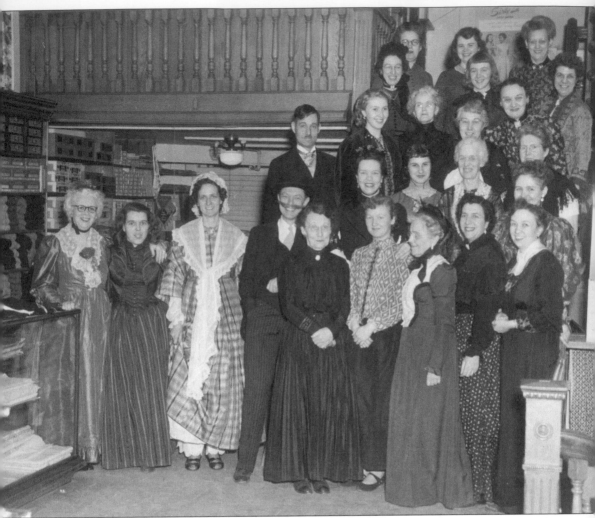

DRESSING UP. Employees of Houghton and Simonds clothing and dry goods store at 139 Main Street dress for a promotional event sponsored by the store *c.* 1951.

Two

MAKING MONEY

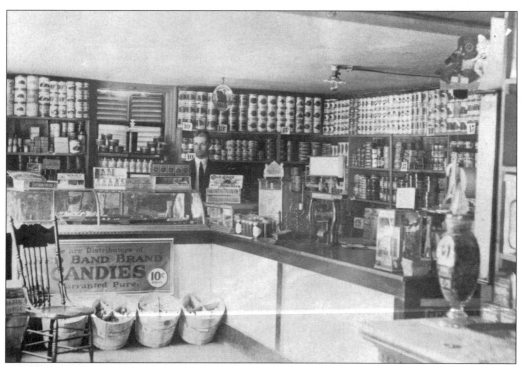

THE INTERIOR OF JASON BUSHNELL'S STORE ON FLAT STREET. Jason Bushnell opened his store on Flat Street in 1900 at the age of 19. In 1915, he moved the business to Elliot Street in the building referred to as the Bushnell Block, across from the present fire station.

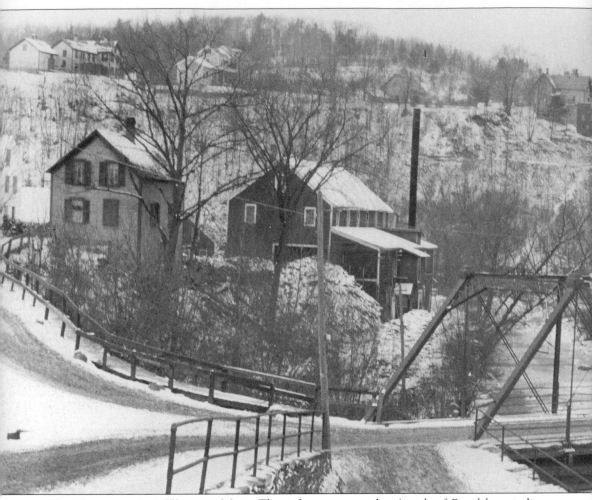

THE BRATTLEBORO WOOLEN MILL. The information in the *Annals of Brattleboro* indicates that, in 1847, the Brattleboro Woolen Mill on Birge Street was owned by P.T. Clark, with F.A. Wheeler, agent. In 1865, it was owned by Whittemore and Davis of Springfield and was run by Frost and Good of Brattleboro. The Jordan and Marsh Company of Boston acquired the mill in 1866, with J.W. Frost acting as agent. The production of Balmoral skirts was a specialty.

The building that housed the mill still exists on the bank of the Whetstone Brook. It was converted to apartments by the beginning of the 20th century. The iron bridge in the right-hand corner has been replaced with a cement structure.

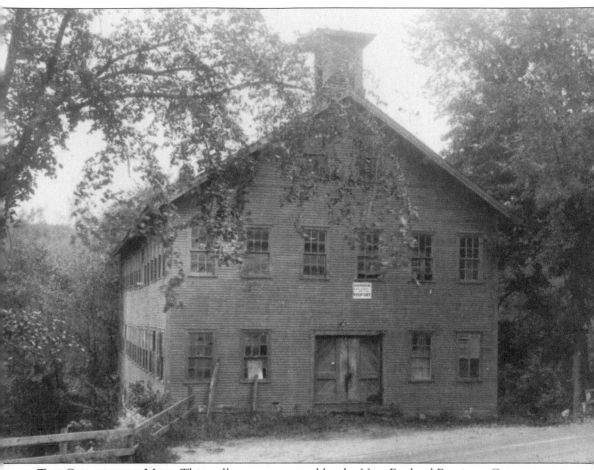

THE CENTERVILLE MILL. This mill was constructed by the New England Furniture Company. Water from the Whetstone Brook provided an adequate supply of power; otherwise, steam power was used. When spring freshets raised the water flow, the mill operated 24 hours a day. It was located at the intersection of Williams Street and Western Avenue in the section of town known as Centerville; it was perched on the rocky ledge next to the brook. This photograph depicts the mill just prior to its demolition in the 1930s. Remains of the foundation can still be seen at the edge of the falls.

The mill served many diversified industries throughout its existence. N.B. Williston manufactured carriages in 1869; a Mr. Wheeler made axes, planing machines, and knives; L. Worcester made tools and machinery. In 1872, furniture was made by Levitt Sargent, H.P. Green, L.W. Hawley, and O.B. Douglas. The Bickford Knitting Company moved to the mill in 1875. By 1899, the Street Railway Company acquired the property for a powerhouse and generated electricity for the trolley.

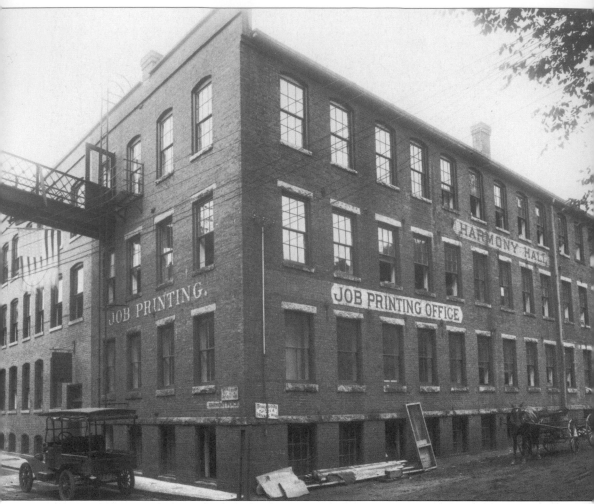

E.L. HILDRETH AND COMPANY. E. L. Hildreth and Company was located in Harmony Hall in part of the area now occupied by the Harmony Place parking lot. The company was listed in the 1881 town directory under Printers, Book and Job: Leonard Dewitt, Harmony Block. Following buyouts of early partners, E.L. Hildreth became sole owner of the company in 1910. The business developed and expanded until it became one of the larger printing establishments in New England. A connection with Yale University Press began in 1910 and a long relationship followed, due to the high quality of the typography and presswork. The name Hildreth was associated with printing at this location from 1887 until 1949, when the company then known as Hildreth Press moved to Bristol, Connecticut.

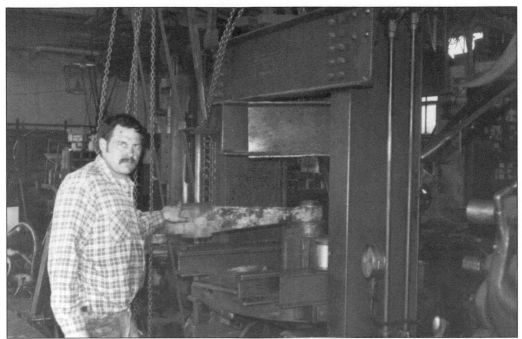

DUNKLEE'S MACHINE SHOP. Amid equipment of current and bygone days, Lester Dunklee continues to operate the Flat Street machine shop purchased by his grandfather Robert E. Dunklee in 1922. Three generations of Dunklees, primarily Robert, David, and Lester Dunklee, have provided machine repair and custom metalwork for their customers at the Dunklee and Sons Machine Shop. In a 1977 interview with a *Brattleboro Reformer* reporter, David Dunklee was quoted as saying, "As long as there are machines, people will have to have things repaired."

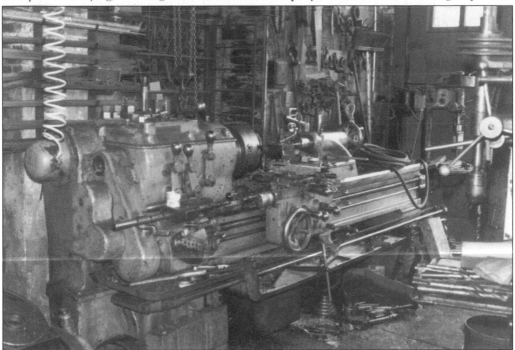

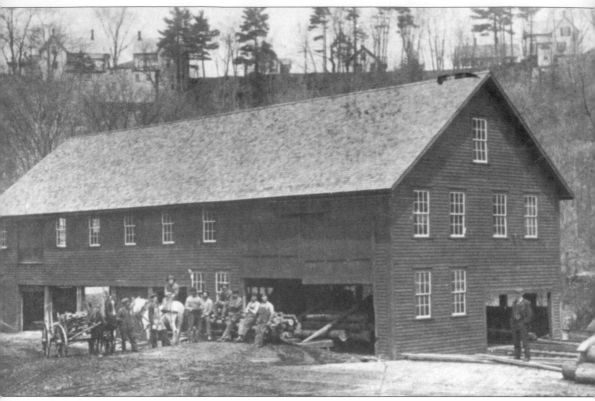

THE HOLDEN & MARTIN LUMBER COMPANY SAWMILL. The sawmill was located at the end of Birge Street, on a section of road referred to as Sawdust Alley, next to the Whetstone Brook. It was constructed by Lyman Holden and J.L. Martin in 1904 and was listed in Manning's town directories as late as 1958. Water was channeled from the brook around the back of the yard and through a penstock to the mill. A combination of water and electricity was used for power.

For a number of years, a huge sawdust pile existed between the mill and the brook, as well as a sawdust burner along the brook's bank; the concrete base is still there. There was limited use of the lumberyard for a number of years, but the sound of whining saws and spraying water has been replaced by modern forklifts and large trucks hauling flatbed trailers of lumber for Cersosimo Lumber Company.

The houses along Western Avenue, just west of Union Hill, look down on the brook and the mill.

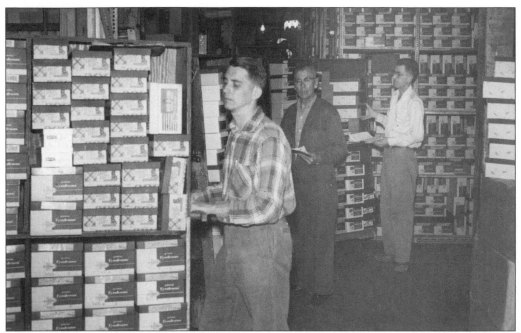

THE DUNHAM BROTHERS COMPANY. With an investment of $2,500 in 1885, George and Charles Dunham established a retail shoe store on Main Street. They expanded into the wholesale market in 1900. Lyndon Dunham joined his brothers in 1894. Two six-story warehouses behind the Main Street location were constructed to handle the increasing wholesale business. This 1950 photograph shows Ray Pratt, Chet Newton, and Harry Capen filling an order for shipment.

FOOTWEAR COMING AND GOING. In the 1950s, countless shoes and boots entered and left the warehouse by trailer truck. Main Street traffic would come to a complete stop when truckers maneuvered their rigs across the street and into the narrow alley.

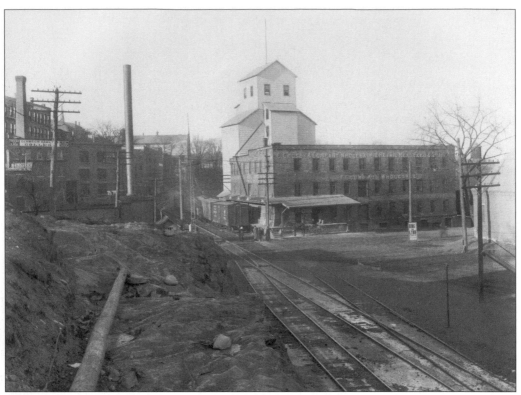

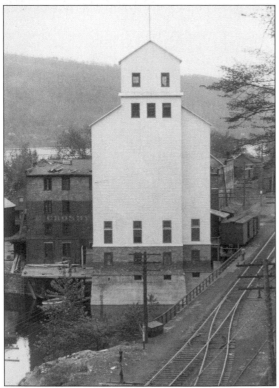

E. CROSBY & COMPANY. This building was constructed in 1887 near the present location of the Riverview Café, replacing an old foundry building. It was described as a "large and substantial storehouse, in a portion of which E. Crosby & Co. has done a successful wholesale and retail business in grain, meal and feed, handling these goods from all points west. The total amount of the firm's business for years approached or equaled $1,000,000 annually, a volume reached by few concerns in the same line of trade in New England."

E. Crosby & Company moved to Vernon Road in 1912; the site is now occupied by Cersosimo Lumber Company.

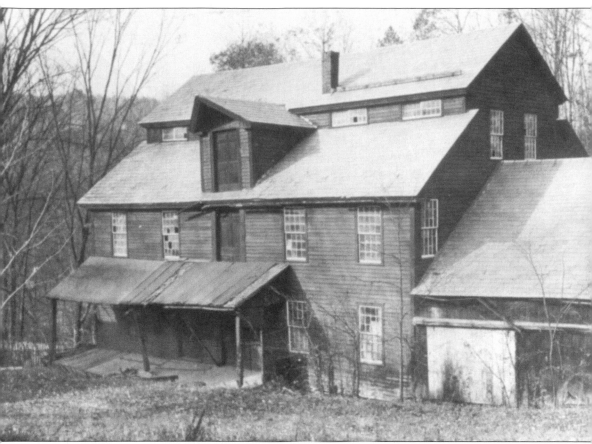

LARKIN MILL. This mill was located downstream, a few hundred yards from the Centerville Mill. It was initially constructed as a paper mill in 1869.

Brattleboro directories as early as 1881 list Henry B. Larkin, for whom the street was named, as a miller and resident at this location. Gene Dary purchased the mill in 1930. He operated a barrel shop and lived on the upper floor. The building burned in the mid-1940s and the ruins were removed.

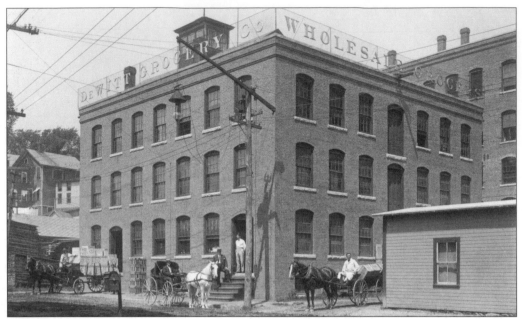

THE DEWITT WHOLESALE GROCERY COMPANY. In 1903, DeWeese DeWitt formed a stock company with J.A. Muzzy of Jamaica and, in 1904, purchased the Emerson and Son storehouse on the north side of Flat Street. The three-story building was badly damaged in a 1922 fire. When repairs were made, a fourth floor was added. The business was listed in the town directories through 1951.

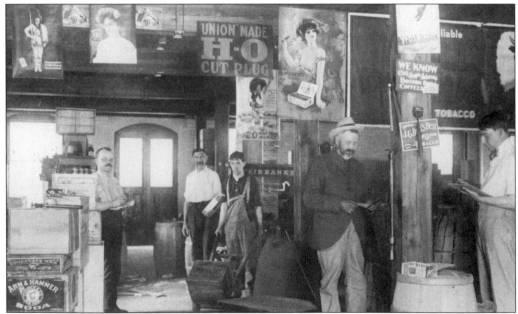

THE INTERIOR OF THE DEWITT WHOLESALE GROCERY COMPANY. DeWeese DeWitt is at the far right. Others in the 1906 picture are, from left to right, Milton H. Eddy, first bookkeeper; David Corey, who worked for the company for 25 years; Holland J. Wilson; and Melvin Smith, a West Chesterfield merchant. Some familiar products were included in the company's stock. A Fairbanks scale manufactured in St. Johnsbury appears in the background.

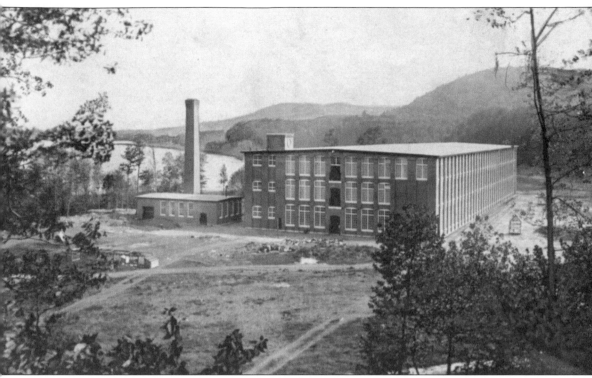

THE FORT DUMMER MILL. The construction of the Fort Dummer Mill at the south end of town in 1910 was facilitated by the recent installation of the Vernon Dam with its readily accessible electric power. Originally, the mill manufactured high-grade cotton goods for women's shirtwaists. Town directories list the mill occupant as Berkshire Fine Spinning Associates from 1931 through 1958. The main structure and adjacent buildings now house a number of small business enterprises as diversified as a dance school, a fitness center, technology firms, and food companies.

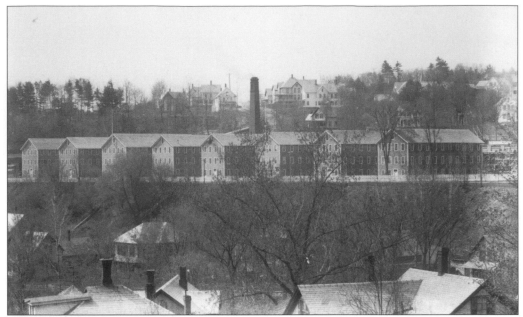

THE ESTEY ORGAN COMPANY. From the 1850s to the 1950s, the Estey Organ Company produced instruments that can still be found around the world. The company's name and location are prominently displayed on each organ. The factory was located on the higher ground of Birge Street in 1870, following floods and fires at previous downtown locations. The 1905 photograph, above, depicts the original eight slate-covered buildings. The two at the far right were later combined. The houses of Esteyville, homes for many Estey employees, are at the top of the hill. Today, the Estey slate-covered buildings are used by the town school district, small businesses, and a church group.

The *c.* 1915 photograph below shows a truckload of Estey organs on its way to customers . One crate indicates organ number 400,000.

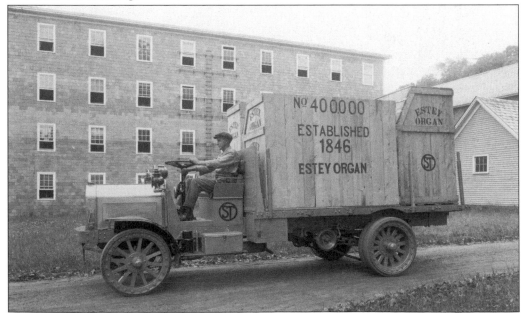

Three

HOSPITALS AND ALTERNATIVE MEDICINE

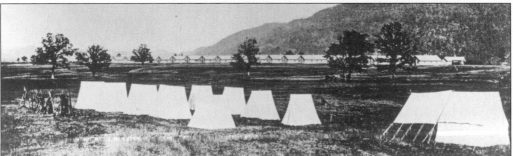

A CIVIL WAR HOSPITAL. On January 5, 1863, an order was issued by the U.S. General Hospital to establish a military hospital in Brattleboro. Ten large barrack buildings were to be constructed and fitted in a proper manner, forming a large hospital of about 500 beds. With the Brattleboro hospital in operation, Vermont sick and wounded soldiers were transferred back to their home state. The grounds also served as the mustering-in and mustering-out headquarters.

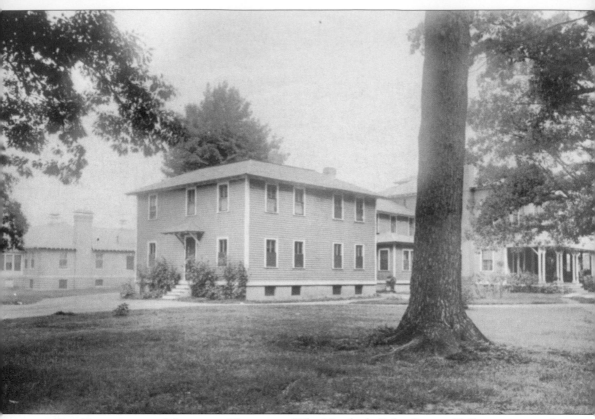

THE BRATTLEBORO MEMORIAL HOSPITAL. "The Hemlocks," the George Hall mansion on the hill off Canal Street between Maple Street and Belmont Avenue, has evolved over the years into the Brattleboro Memorial Hospital. In 1902, a bequest from Thomas Thompson of Boston provided for the purchase of the property and the establishment of an infirmary for sewing women and shop girls. It was originally named the Hemlocks Hospital, but was renamed within a couple of years.

The first patient admitted to Brattleboro Memorial Hospital, after the name change, was Vance Nuckels, a race driver who fractured his leg in an accident at Valley Fair in September 1904.

A monument at the entrance of the hospital acknowledges the Thompson family generosity. Part of the original structure appears at the right of this early photograph.

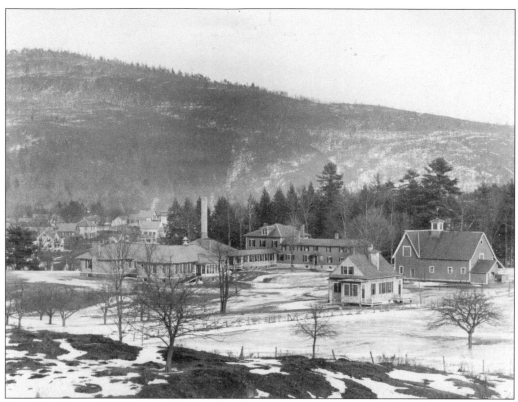

THE DEVELOPMENT OF THE HOSPITAL. The upper photograph shows an overview of the hospital grounds. The lower one shows the area as it had developed by the 1920s.

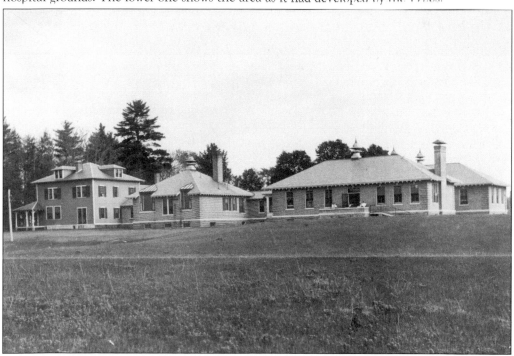

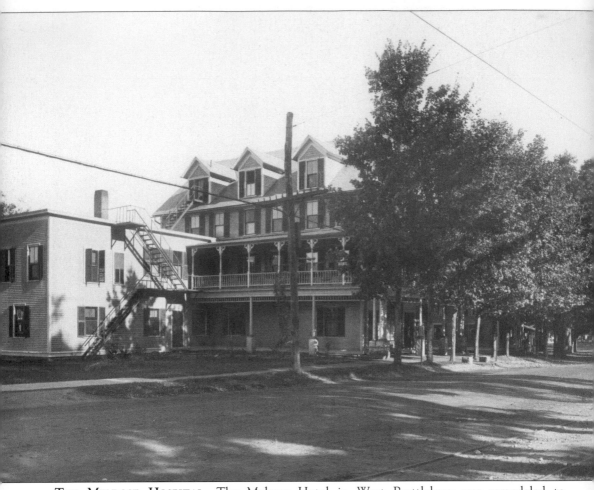

THE MELROSE HOSPITAL. The Melrose Hotel in West Brattleboro was remodeled to accommodate a modern hospital for Dr. E.R. Lynch in 1907. There was space for 30 patients. Ten nurses and support staff were employed. A wing was built on the north side of the hotel and an extension added to the back of the Queen Anne-style building. The Melrose Hospital was in operation through the 1920s. The property later became the Tally Ho Inn and then the Village Green.

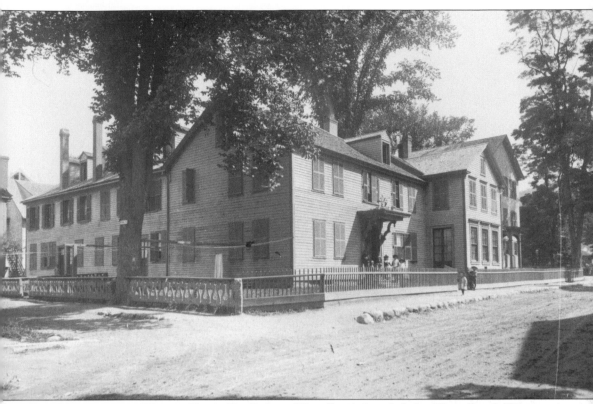

THE WESSELHOEFT WATER CURE. Dr. Robert Wesselhoeft founded the Wesselhoeft Water Cure in 1844. He purchased two buildings on Elliot Street, the present site of the fire department. Before coming to Brattleboro, Wesselhoeft had been conducting successful experiments with hydrotherapeutics for some time. He found the water ideal for his needs, in that it was the purest to be found in springs from Virginia to the White Mountains. By the spring of 1846, there were 392 guests at the water cure.

After Wesselhoeft's death in 1852, declining interest in the rugged treatments and fewer patients forced his wife and son to give up the business. Another water cure was attempted across the street, the Lawrence Water Cure, but it was short-lived. By 1890, the Wesselhoeft building was converted into tenements, as shown in the photograph above.

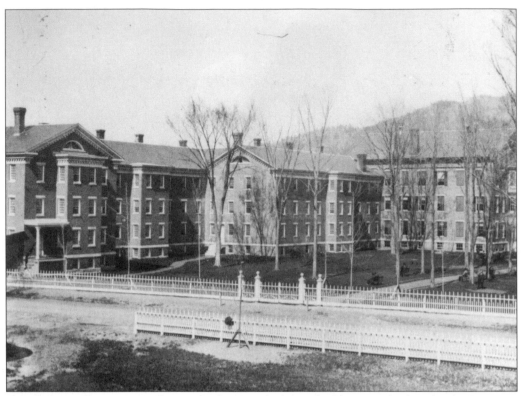

THE ASYLUM BUILDINGS. The upper photograph shows the Vermont Asylum for the Insane *c.* 1857. It was taken from across Linden Street. The lower photograph, dating from the late 1870s, shows the center section of the main building, with the fenced-in fountain in the left foreground. Eventually, the asylum was renamed the Brattleboro Retreat.

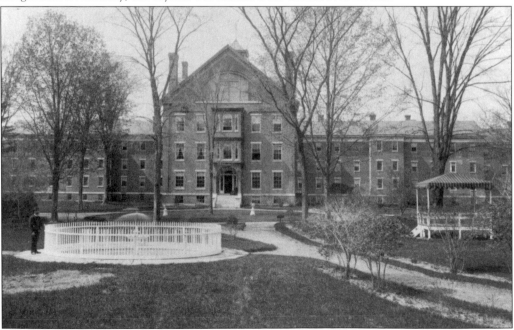

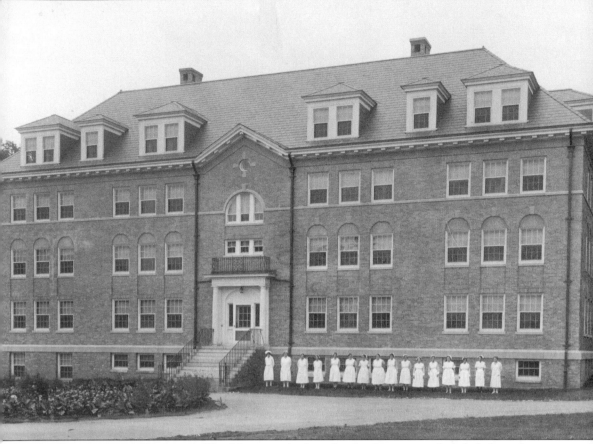

THE BRATTLEBORO RETREAT. The Vermont Asylum for the Insane was founded through a bequest of $10,000 from Anna Marsh of Hinsdale, New Hampshire. It was incorporated by the Vermont Legislature in 1834. The name was later changed to the Brattleboro Retreat. More than 20 miles of nature trails, footpaths, and carriage roads were laid out around the hospital so that patients could go on daily carriage or sleigh rides and exercise walks. Male patients worked in the gardens, fields or orchards, the woodlots, the dairy barns, or at general maintenance tasks. The women participated in needlework and other indoor occupations of a soothing nature.

This asylum building is the Ripley Nurses Home. It was constructed in 1929 with broad verandahs leading from each floor to provide outdoor living rooms where employees could rest and relax.

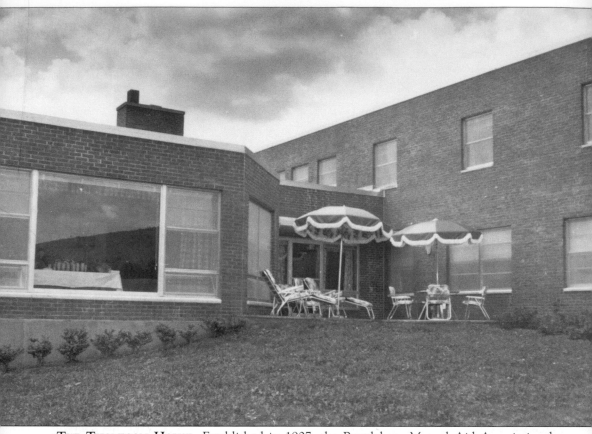

THE THOMPSON HOUSE. Established in 1907, the Brattleboro Mutual Aid Association has been an important factor in the health of the community. From its beginnings in the Thompson House on Harris Place to its building on Maple Street, erected in 1958, it has served convalescent and long-term patients. The present Thompson House, one of the most modern fireproof buildings of its kind in Vermont, was financed by the Thompson Trust and by grants from federal funds for a total cost of $690,000. The Thompson School for Practical Nurses is associated with this facility.

Four

OUR BEST MANORS

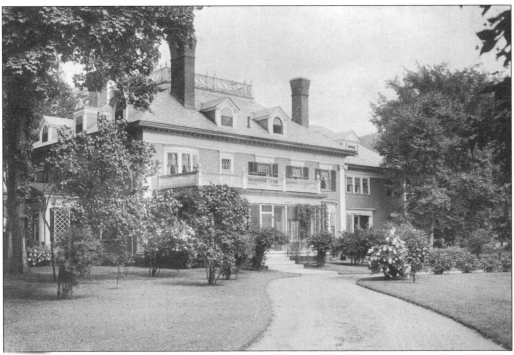

THE HOME OF J. HARRY ESTEY. This Colonial Revival building was erected in 1895 by J. Harry Estey, the grandson of Jacob Estey and the founder of Estey Organ Company. Born in 1874, he became treasurer of Estey Organ at the age of 18. He married Allethaire Chase in 1895 and, to mark the occasion, he built the house on Putney Road. He died in 1920. The house was purchased in 1929 by the Loyal Order of Elks. Still occupied by the Elks, the building has undergone some renovation to suit the purposes of a fraternal organization. An Estey organ is still on the premises.

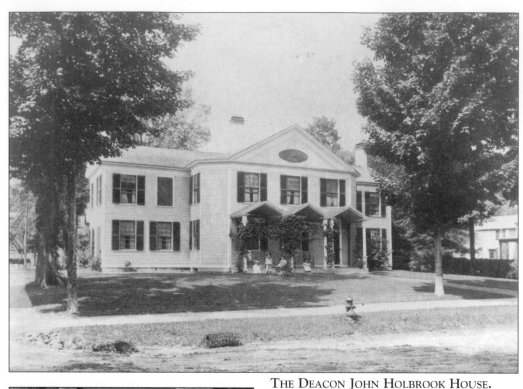

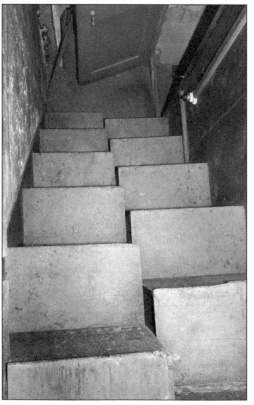

THE DEACON JOHN HOLBROOK HOUSE.
This house was built in 1825 for well-known
local publisher Deacon John Holbrook.
One of its many features is a set of "witches
stairs," left, shown from the top looking
down. The stairs lead from the second floor
to the attic and have 18-inch risers and 6-
inch treads. Each step is spaced to the side of
the previous one to prevent the witches from
coming down into the main part of the
house. Witches supposedly could not see
their feet and, therefore, could not descend
the stairs safely. Built in the Federal style on
Linden Street, the house was occupied by
numerous members of the Boyden family over
the years until it was purchased by attorneys
Downs, Rachlin, & Martin and converted
into office space in 1995.

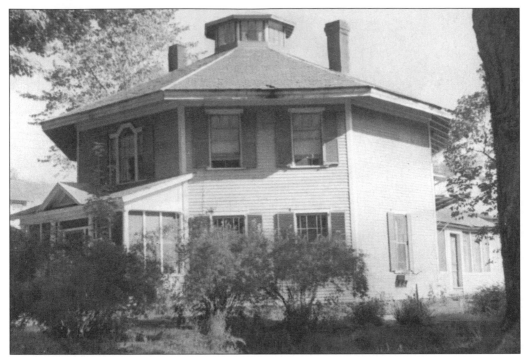

THE OCTAGON HOUSE. This particular house was built by Rev. Joseph Chandler Sr., while pastor of the West Brattleboro Congregational Church (1846–1872). Designed by O.S. Fowler of New York, the octagon shape was based on the principle that nature's forms are mostly spherical; the octagon is the nearest practical approach in carpentry to the circle. Rooms were large and square with two windows in each and many doors that led from one room to another. It was known for generations as the Torrey House. It was razed between 1965 and 1970 to build the entrance to Melrose Terrace Elderly Housing.

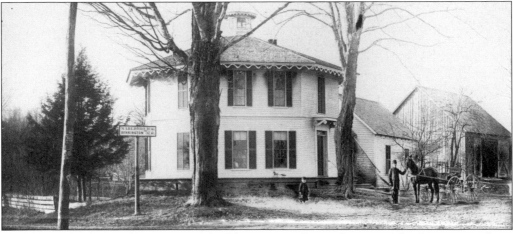

ANOTHER OCTAGON HOUSE, C. 1890. This octagon house, known as the Davenport place, was also designed by O.S. Fowler, who spent some time in Brattleboro during the Wesselhoeft Water Cure days. In building these houses, Fowler compared the wisdom of the honeybee and its hexagonal form of honeycomb as a selling point for the octagon. It was torn down in the mid-1980s for the office of Dr. David Neumeister, a local dentist located at the corner of Greenleaf Street and Western Avenue.

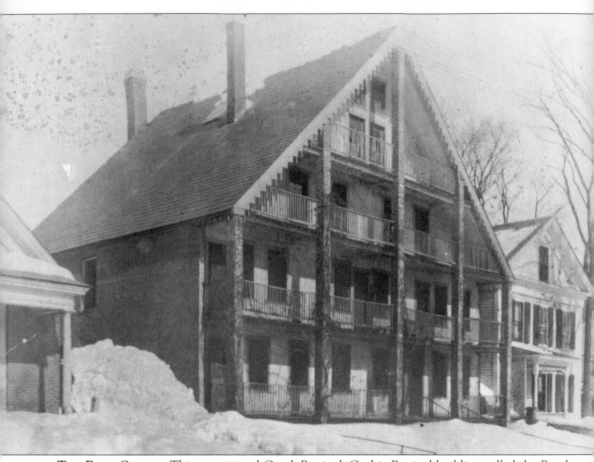

THE REED CASTLE. This transitional Greek Revival–Gothic Revival building called the Reed Castle was built by James Reed and was located on Green Street. Erected as an early apartment house in the 1880s, it was purchased by Mr. Emerson in 1904, razed, and replaced by five cottage houses.

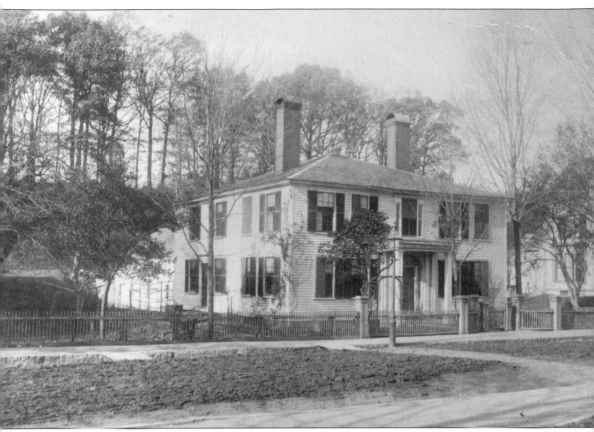

THE GOODHUE HOUSE. Francis Goodhue, an entrepreneur of his time, came to Brattleboro in 1811. Built in 1867, this home was his residence until his death at age 71, in 1839. He spent his life improving the growth and prosperity of the town. The house was torn down in 1886 and a library was erected by George J. Brooks. This distinctive landmark was then demolished in 1971 to make room for parking for the post office.

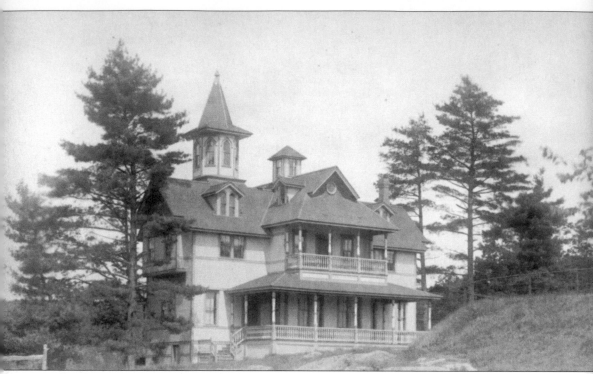

THE FRESH AIR HOUSE. Located on a tract of 30 acres of woodland on Hines Hill, later renamed Chestnut Hill, this house was built in the 1880s to house fresh air children. The Judson Memorial Church in New York sponsored this program. Mrs. George Crowell and Mrs. Julius Estey felt that it was extremely important for disadvantaged youth to have some of the benefits of living in the country. They entertained more than 100 children during the months of July and August for several years. This Stick-style building burned down in 1913.

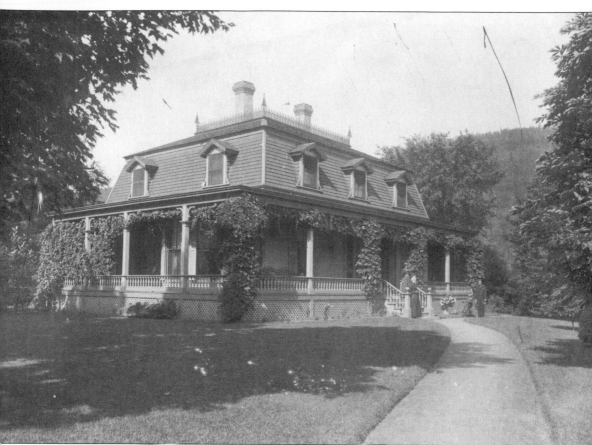

THE THOMAS PICKMAN TYLER HOUSE. Built in the Second Empire style in the 1870s by Diana Tyler, Thomas "Pick" Tyler's second wife, the building housed many generations of Tylers. The tenth son of Royall and Mary Palmer Tyler, Pick Tyler was appointed the historian of the family and devoted his last days collecting and preserving family documents and history. The house is still standing on its original site on Tyler Street. Although the Tylers always painted the house green, the present owners have chosen a more subtle earth-tone color scheme.

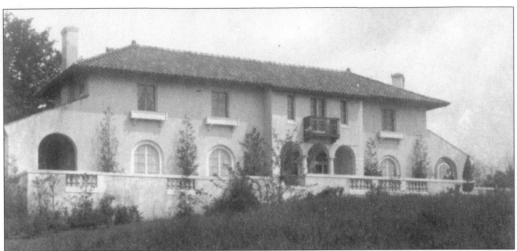

THE CHANTRY. This villa was built in 1916, for banker Edmund Pratt and his wife Stella Brazzi, an internationally acclaimed opera diva. Edmund Pratt commissioned New York architects Wilder and White to design and build the villa. John and Isabel Dunham acquired the villa in 1936. Dunham was a well-known and respected businessman who owned a shoe company. In 1998, Jaye Muller purchased the property and he and his partner Jack Rieley have renamed their home the Chantry after an old English word referring to the place where music is created.

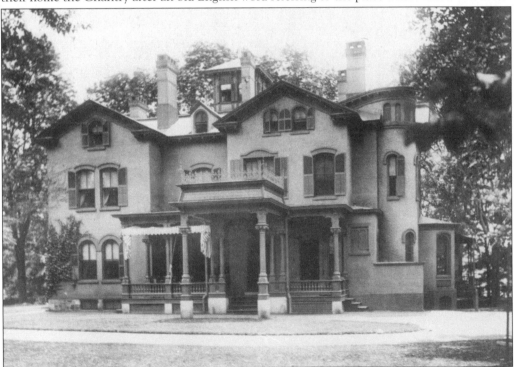

FLORENCE TERRACE, THE HOME OF JULIUS ESTEY. This house was designed by architect Richard Upjohn in the Italianate style. It was built for John Stoddard in 1853 on what is now School Street. The house was later acquired by Julius Estey, who named it Florence Terrace in honor of his wife. The building was demolished in 1971 and was replaced by the Moore Court Housing Complex.

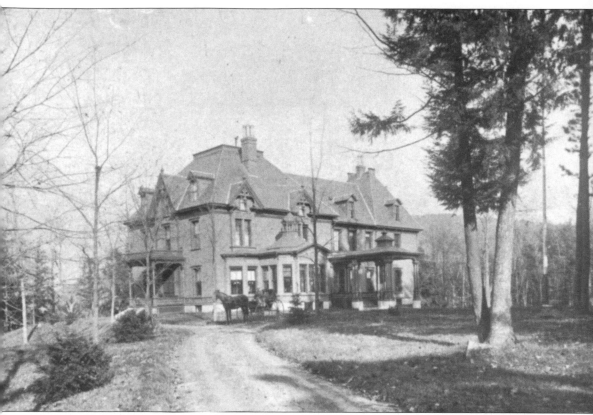

PINE HEIGHTS. Pine Heights was built by Levi K. Fuller in 1876. It was located off Canal Street near the present-day hospital. The ornate exterior was matched only by the lavishness of the interior and the structure's commanding view of the town. Because of his affiliation with the Estey Organ Company, Levi Fuller had amassed a huge collection of tuning forks. During his final days, Governor Fuller occupied his time with his collection and his telescope, which was considered to be the finest in the eastern United States. The house was torn down in the mid-1970s, but its library was salvaged and installed in a house on Fuller Drive. The Canal Street site is now occupied by Eden Park Nursing Home and its adjoining parking lot.

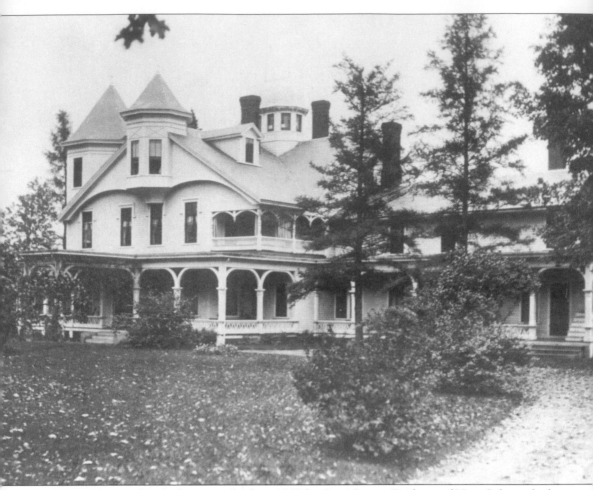

LINDENHURST. Lindenhurst was built in 1859 by Gen. Simon Buchner of New Orleans for his son-in-law J.B. Eustis, an U.S. senator from Louisiana. Buchner had come to Brattleboro for the Wesselhoeft Water Cure. The title passed in 1871 to Prof. Elie Charlier, the founder of the Charlier Institute in New York City, one of the foremost boys' schools in the 1870s and 1880s. It was sold in 1886 to George Crowell, publisher of the *Household*, a women's magazine. It served as the Crowell family home until 1926. Hard times caused the house to be razed in 1936 by Vermont National Bank, the owner at the time. Located at the top of Green Street, it is now the site of a playground known as the Crowell Lot.

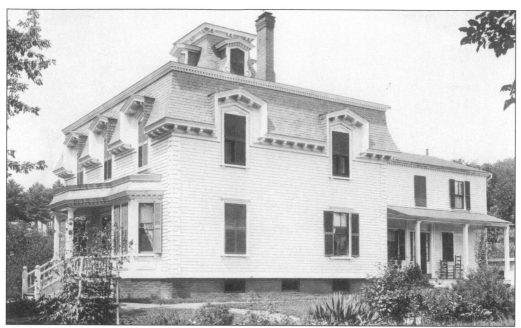

THE PARLEY STARR RESIDENCE. This Second Empire-style house on Western Avenue was built in 1873 by Parley Starr, the first president of Peoples National Bank. In 1901, Morton Starr Cressy, a grandson of Parley Starr, accidentally shot and killed his college classmate Sidney Bristol. The theory was that Bristol was a somnambulist and, in his sleep, seized Cressy. The struggle resulted in Bristol's death. The event was covered by many surrounding newspapers. In 1994, the house was converted to a funeral home .

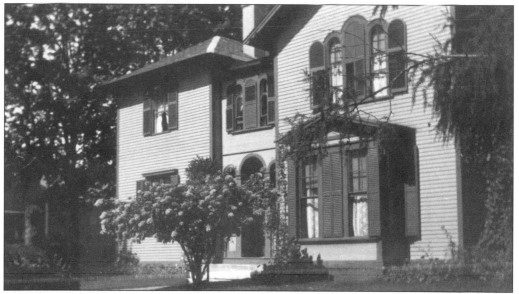

THE CHARLES ROYALL TYLER HOUSE. Erected in 1856, this was the first house in the surrounding area of Terrace and Tyler Streets. Charles Royall Tyler and his wife, Laura Keyes Tyler, remained in their home until they died—he in 1896, and she in 1906. Local contractor Ernest Hall purchased the property in 1908 and demolished it. In its place, he built a four-square-style house, which still stands.

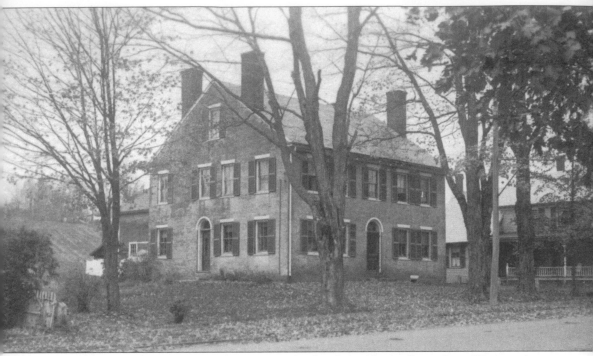

THE JEREMIAH BEAL HOUSE. This intact Federal-style building still stands on Western Avenue in West Brattleboro. It was bequeathed to the Brattleboro Historical Society in 1999 by local businessman Larry Cooke, who passed away in April 2000 at the age of 57. The house was completed *c.* 1805 by Jeremiah Beal and may be one of the earliest surviving brick structures in Brattleboro. Beal operated a tannery on the property and was one of the founders of the Universalist church, located across the road, which is now a Baptist church. Beal's home was later used as a farmhouse and a tourist inn called the Colonial Home. It is also possible that the house was a stop on the Underground Railroad. The investigation of a reported tunnel from the basement to the church across the street is a future project for the historical society. Of course, it is also possible that this tunnel was created to hide a bootlegger's still during Prohibition.

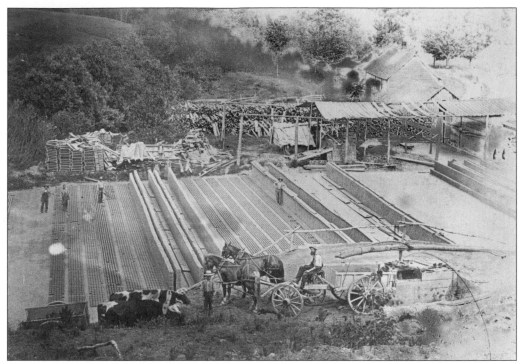

THE H.A. AKELEY BRICKYARD. Main Street, Brattleboro, is famous for its collection of 19th-century brick structures. However, none is as old as the West Brattleboro Jeremiah Beal House. It is possible that the bricks for the Beal House came from this brickyard on Ames Hill Road in West Brattleboro, which operated until the 1870s.

WEST BRATTLEBORO BEFORE THE AUTOMOBILE AND PAVED ROADS. The Beal House is seen behind the lone horse-drawn wagon in this late-19th-century photograph of West Brattleboro village, formerly called West Village. On the left is the Brattleboro Green. Despite the fact that Western Avenue is part of a major east–west route through Vermont today, the village retains its historic character. The Beal House has also retained its historic character, with Federal-style features such as formal symmetry, five-bay center-hall plan, fanlight windows in arched doorways, multiple gable-tall chimneys, and period fireplace mantels.

71

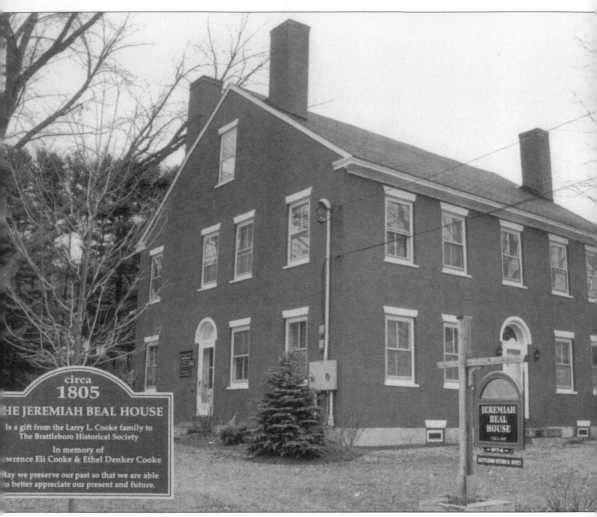

The sign on the building reads:

circa
1805
HE JEREMIAH BEAL HOUSE
Is a gift from the Larry L. Cooke family to
The Brattleboro Historical Society
In memory of
wrence Eli Cooke & Ethel Denker Cooke
lay we preserve our past so that we are able
o better appreciate our present and future.

JEREMIAH
BEAL
HOUSE
CIRCA 1807
— 974 —
BRATTLEBORO HISTORICAL SOCIETY

THE JEREMIAH BEAL HOUSE. This photograph shows the house as it appears today.

Five
RIVERS, BRIDGES, AND TRANSPORTATION

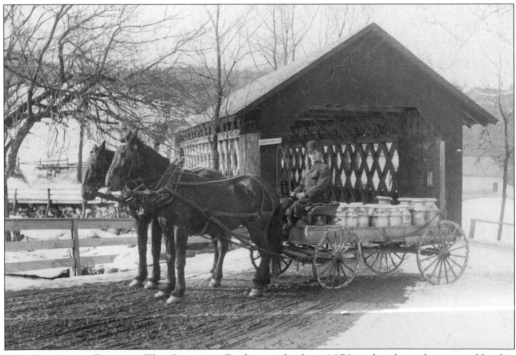

THE CREAMERY BRIDGE. The Creamery Bridge was built in 1879 and is the only covered bridge in Brattleboro that is still standing. It spans the Whetstone Brook near where the Brattleboro Creamery once stood and connects Guilford Street with Western Avenue. It is the only bridge in Windham County with a slate roof. A covered sidewalk was added *c.* 1917.

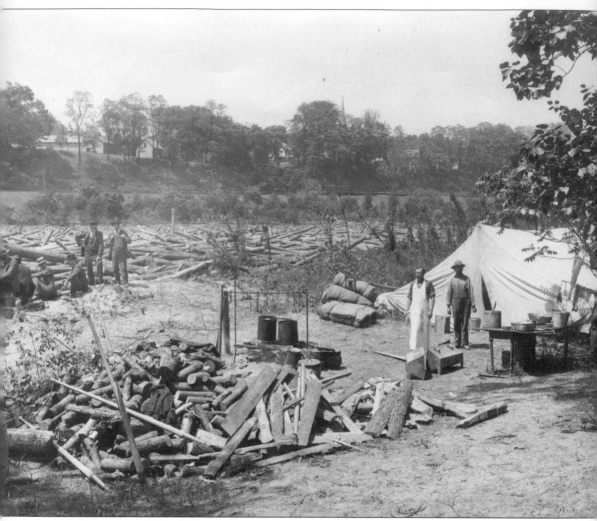

A LOG DRIVE. From 1869 until 1915, there were log drives on the Connecticut River that passed Brattleboro on their way to the mills at Turners Falls and Holyoke, Massachusetts. Loggers would camp on the island across from Brattleboro. This photograph shows their camp with its cooking tent. The river can be seen in the background, filled with logs. By 1915, too many dams and bridges had been built for the big log drives to continue. However, in 1914, near the end of this era, 60 million board feet and 30,000 cords of pulpwood floated past Brattleboro.

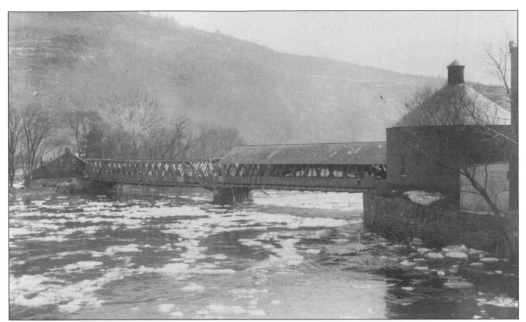

THE HINSDALE TOLL BRIDGE. This 1902 photograph shows the Hinsdale Bridge that was constructed after the previous covered bridge at this site was taken out by the 1862 flood. The eastern half of the roof has been removed (and eventually the whole roof was removed) to reduce the total weight. The span carried the road from Bridge Street in Brattleboro to the island. A toll was collected at the river crossing until 1888; the bridge was administered by a private corporation. In May 1902, a huge logjam occurred at this bridge and the entire logging crew gathered to force the logs downstream, while townspeople looked on.

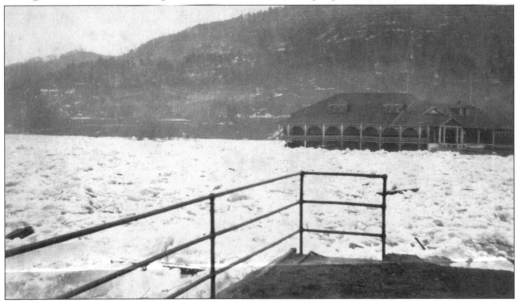

THE OLD HINSDALE BRIDGE IS NO MORE. In 1920, the bridge from Brattleboro to Island Park, which connected Brattleboro to Hinsdale, went to the bottom of the river because of ice brought down by the flood. While the bridge was replaced with a new steel one, the Island Park Amusement Park never reopened, because much of the island also washed away.

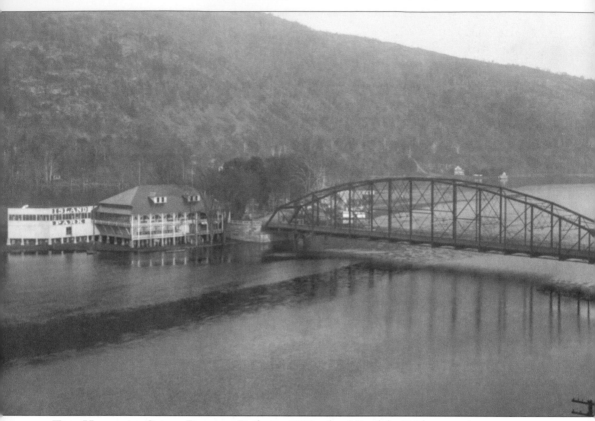

THE HINSDALE STEEL BRIDGE. Built in 1920, the Hinsdale Bridge continues to connect Brattleboro to New Hampshire. Currently, plans are under way to build another bridge a short distance to the south and to make the 1920 bridge a pedestrian walkway.

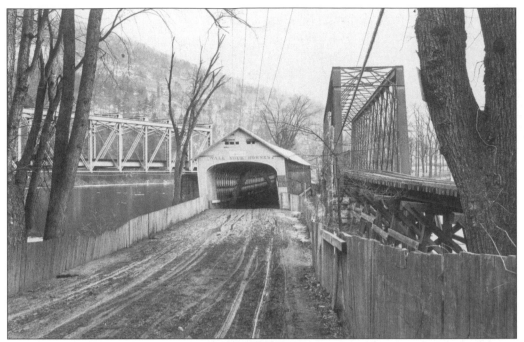

THE WEST RIVER BRIDGES. Three bridges crossed the West River where it joins the Connecticut River. The one on the left was for the Boston and Maine Railroad; the one in the middle was for carriages; the one on the right was for the narrow-gauge West River Railroad.

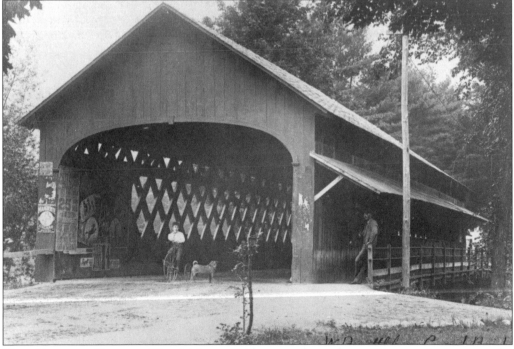

THE MELROSE BRIDGE. The Melrose Bridge was located on Western Avenue at the intersection of Melrose Street. Like many covered bridges, it was replaced with a concrete structure. This 1908 photograph shows the bridge in operation.

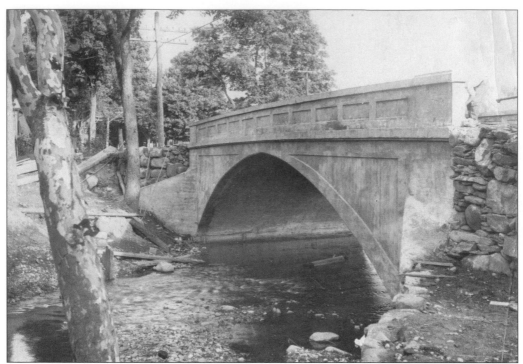

THE CONCRETE MELROSE BRIDGE. Seen as an improvement, this type of construction replaced many wooden bridges. Although the concrete ones were undoubtedly easier to maintain, something seems to have been lost in aesthetics.

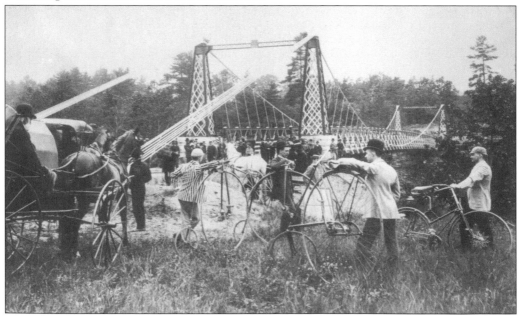

THE 1889 SUSPENSION BRIDGE DEDICATION. This suspension bridge, crossing the Connecticut River on Route 9, connects Brattleboro to West Chesterfield, New Hampshire. It was constructed in 1889 and was destroyed in the 1936 flood. A remnant abutment from this bridge is just south of the present steel bridge.

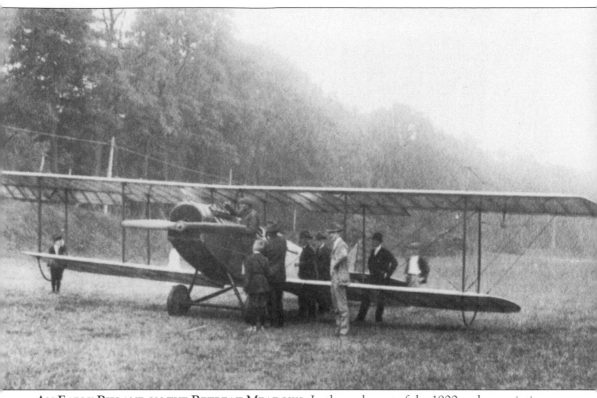

AN EARLY BIPLANE ON THE RETREAT MEADOWS. In the early part of the 1900s, when aviation was first developing, Brattleboro was not to be left behind. The town's Valley Fair organizers took advantage of this interest and arranged for stunt pilots. Planes flew over the fairgrounds (the site of the present Brattleboro Union High School) and performed loops and spiral dives to the crowd's delight. The Retreat Meadows was used as an airfield until September 1931, when businessmen and aviation promoters opened an airport for Brattleboro known as Crowell Field, located on Putney Road.

THE RAILWAY EXPRESS. Brattleboro first had railroad service on February 20, 1848, when a train carrying 1,500 passengers arrived. Brattleboro has had three railroad stations: the first was built in 1849; the second, a more ornate one, was completed in 1881; the third one, with a sizable freight facility, pictured here, was built in 1915.

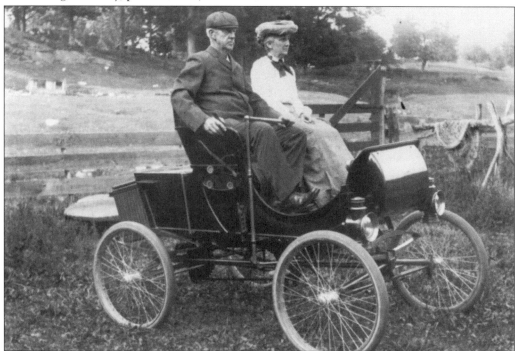

A TEAKETTLE ON WHEELS. Seated in a *c.* 1901 Steamobile at their West Dummerston home are Mr. and Mrs. George Norcross. He was superintendent of the S.A. Smith Toy Co. in Brattleboro and was also a local photographer. This tiller-steered runabout carried a price tag of $850 and was probably one of Brattleboro's first automobiles. The Keene Steamobile, as it was first known, was designed and built beginning in 1900, by Reynold Janney, proprietor of the Trinity Cycle Manufacturing Company of Keene, New Hampshire.

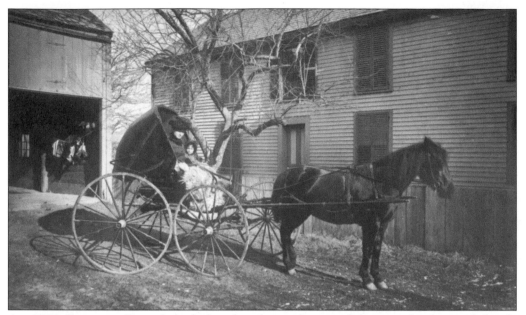

AN 1883 CARRIAGE RIDE. Long before the advent of two- and three-car families, with family members all going their own way, the carriage ride was special. Prepared to take a ride down Green Street on December 12, 1883, are Florence Farr and Matilda. They are taking advantage of the fact that snow has not yet arrived in Brattleboro.

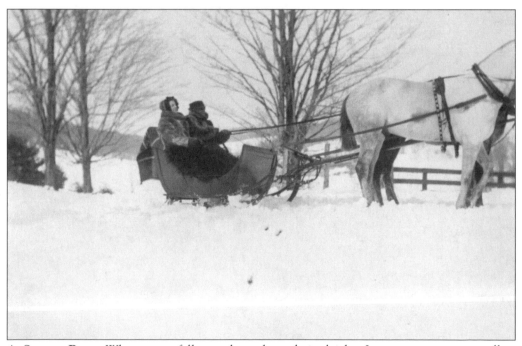

A SLEIGH RIDE. When snow fell, people took to their sleighs. In some areas, snow rollers were used to pack the snow down to make the road more passable; however, in many cases, the family sleigh and horse team made their own way. Fur coats and lap robes were standard equipment.

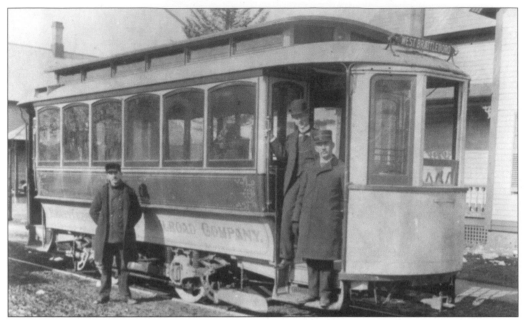

A TROLLEY RIDE. The first Brattleboro trolley appeared in May 1895. It was very popular and carried approximately 2,500 people daily. There were two trolley barns: one in Centreville and one on Pine Street. Service extended to West Brattleboro, as shown in this *c.* 1905 photograph.

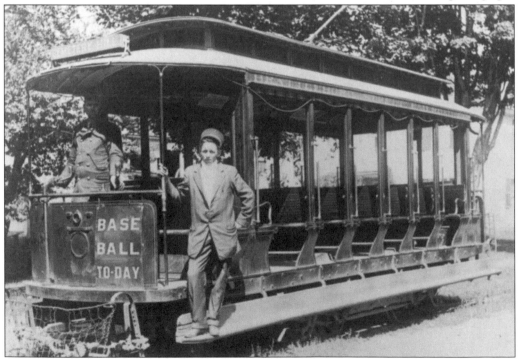

TAKE THE TROLLEY TO THE BALL GAME. Baseball, a popular event in Brattleboro, was played at Island Park. Many people used the trolley to get to the ballpark. The trolley promoted such travel by advertising the game, as shown in this *c.* 1900 photograph. By 1923, the trolleys had been replaced by buses.

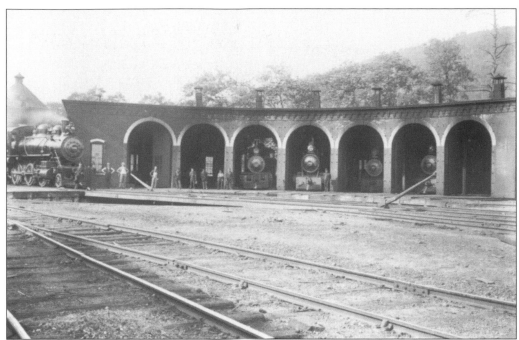

BOSTON AND MAINE'S ENGINE HOUSE. Brattleboro's railroad station area was a busy place. The Boston and Maine Railroad's need to store and service locomotives was addressed in Brattleboro. This July 4, 1909 photograph shows the seven-bay engine house on Vernon Street. The structure was also called a roundhouse because of the large track turntable that was used to reverse the direction of the locomotive. Notice the smokestacks on the roof of the building that aligned with the smokestack of the locomotive.

A GATE ATTENDANT. Today, automatic gates are used prevent accidents between automobiles and trains. In bygone days at busy intersections such as this one on Bridge Street, people relied on the services of Eugene Ferriter and other gate attendants.

THE BRATTLEBORO UNION STATION. This photograph was taken in 1915, soon after the station was first opened.

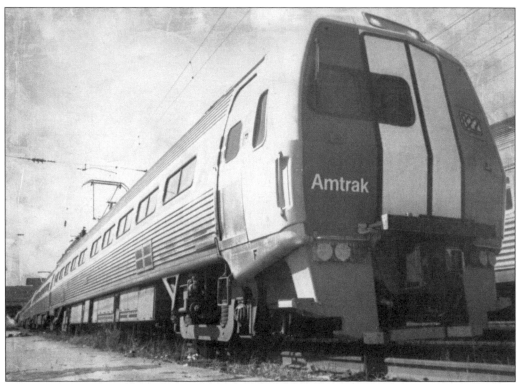

AMTRAK. Amtrak arrived in Brattleboro in 1972.

Six

SCHOOLS

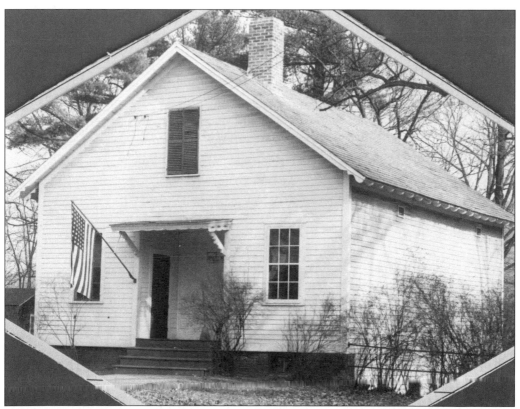

NEIGHBORHOOD SCHOOLS. One- or two-room schoolhouses were scattered around town to serve the educational needs of particular neighborhoods. This photograph of the Esteyville School, taken in 1953, illustrates the typical design of the buildings. With consolidation into larger facilities, a number of the small schools were converted to residences; however, the Esteyville School remains part of the local school district with a preschool program.

THE ACADEMY SCHOOL. A succession of educational institutions occupied the West Brattleboro property on which the wooden Academy School stood until 1957. From 1802 to 1815, the Brattleborough Academy prepared boys for college. In the years after the school closed, the second floor was rented to cabinetmaker Anthony Van Doorn. The space later served as a town hall, until 1855, when a new town hall was built in the "East Village." The 1802 building was razed *c.* 1900. The building in this 1953 photograph was one of three structures on the property in the mid-1860s. It became a public school in 1901. In 1941, a renovation project was undertaken to solve overcrowding problems as the school population had risen to 142. When a modern one-story school was constructed on nearby property behind the First Congregational Church in 1958, the wooden building was demolished and burned. The only indication of its existence are the remains of the front sidewalk and the flagpole hidden among the trees.

THE GLENWOOD LADIES' SEMINARY. The Glenwood Ladies' Seminary, established in West Brattleboro in 1860, included the former Brattleborough Academy building and two additional structures. The building in the photograph above was constructed under the supervision of Hiram Orcutt, the principal. In 1862, there were 80 students. Within five and a half years, 600 pupils studied there, with 110 graduating. Below, four of the school's early students are occupied with various pursuits.

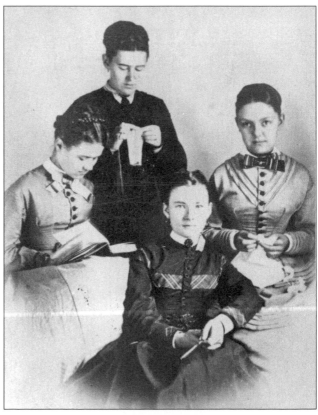

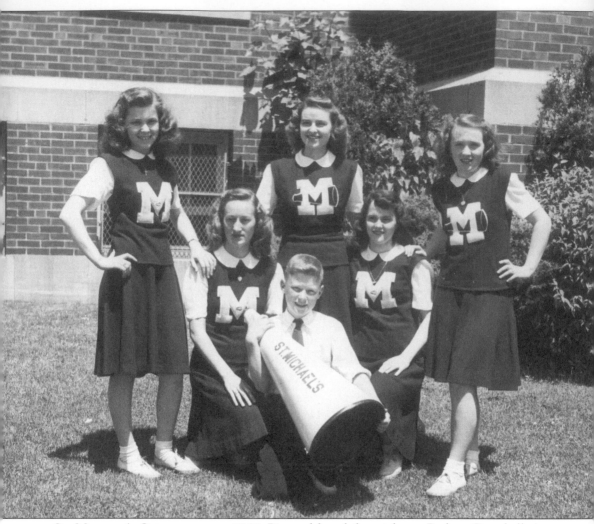

ST. MICHAEL'S CHEERLEADERS, 1947. Pictured from left to right are Barbara Campbell, Agnes Marine, Joseph O'Connor, Elaine LeVasseur, Barbara Murphy, and Maureen Rooney.

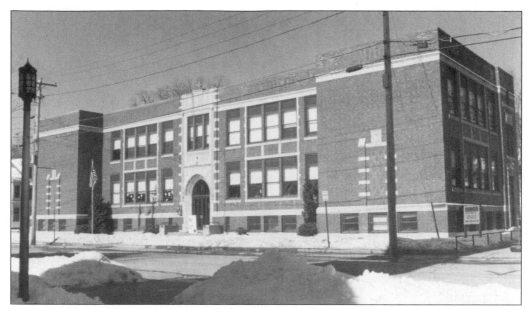

ST. MICHAEL'S SCHOOL. The original St. Michael's Catholic School opened in a large house on Walnut Street. Grades one and two were taught by nuns who lived in the convent next door. Both buildings were razed in 1937. The present school, pictured here, was built on the adjoining property and was dedicated on September 15, 1929. All 12 grades were taught at this site. Athletic activities took place at Rice Field in West Brattleboro.

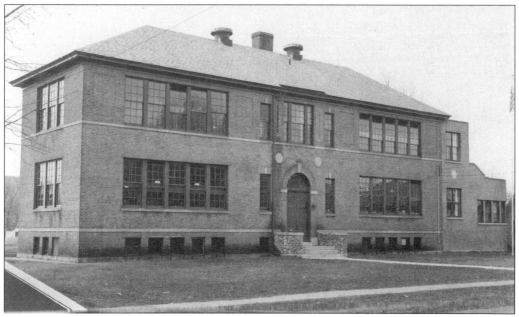

THE OAK GROVE SCHOOL. The Oak Grove School on Moreland Avenue opened its doors in October 1912. The original brick structure contained four rooms, but only two on the first floor were used for classes until the finishing work was completed and the student population increased. For the opening term, 85 students were enrolled in grades one through four. Georgianna McKean taught grades one and two and Edith Douglas taught grades three and four.

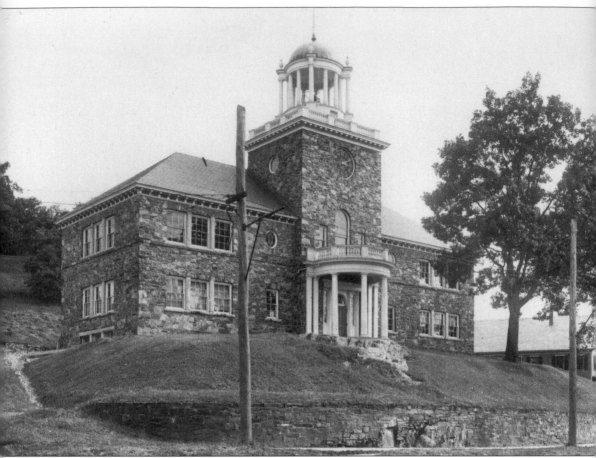

THE CANAL STREET SCHOOL. One of Brattleboro's prized historic buildings listed on the National Register, the Canal Street School has functioned as an educational institution since its construction in 1892. Some residents considered the building too expensive for the part of the village for which it was intended. In spite of some opposition, a special school meeting appropriated $20,000 to cover the cost of the new building, including heating and furnishings. The exterior of the building is mountain stone from Wantastiquet Mountain, just across the Connecticut River from Brattleboro. This 1917 photograph shows the main features of the structure: a central tower and an entrance portico. The clock was financed through subscription. In 1893, the bell, weighing 1,118 pounds, was placed in the tower at a cost of $247.66, with a five-year warranty.

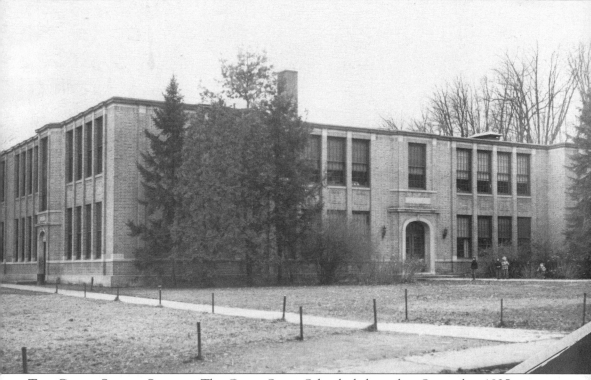

THE GREEN STREET SCHOOL. The Green Street School, dedicated in September 1925, was constructed on property formerly owned by Alonzo H. Hines. The *Vermont Phoenix* described the building style as a modified "Elizabethan Type," as evidenced by the closely grouped windows and the verticality in wall and window-mullion treatment. There were 16 classrooms for grades kindergarten through eight and a center assembly hall with a stage. At the time, the school superintendent's office was located in the building. The cost of the completed structure, ready for use, was within the appropriation of $175,000, with $4,500 left to purchase an adjoining property to square up the site frontage. In recent years an addition was constructed on part of the original playground area to provide a cafeteria and gymnasium; however, the front of the building appears as it did in this photograph taken in 1953.

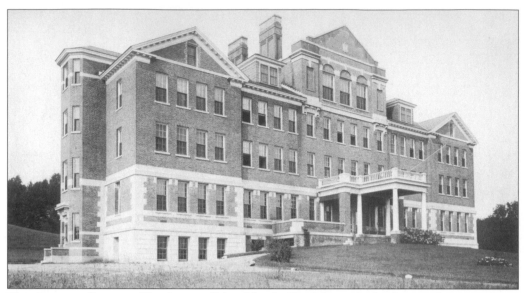

THE AUSTINE SCHOOL. The Austine School for the Deaf, formerly the Austine Institution, was established in 1912 through a bequest of $50,000 from the estate of Col. William Austine, a retired army officer who died in the Brooks House in 1904. The trustees, headed by Dr. Henry J. Holton, purchased the 200-acre Thayer farm on Maple Street for the institution. An impressive Classical Revival-style structure of rough brick and granite was sited on a side hill and afforded extraordinary views to the east and north. The building was designed by Paul Revere Henkel of New York, formerly of Brattleboro. Helen G. Throckmorton served as the first principal. The campus has expanded through the years with modern dormitories, a cafeteria, a gymnasium, and classroom facilities. The Montessori School is also located on this campus. Travelers on Interstate 91 pass directly in front of the school.

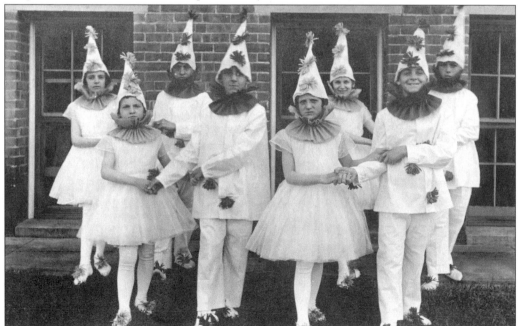

A STUDENT CAST. This cast played in an Austine School production.

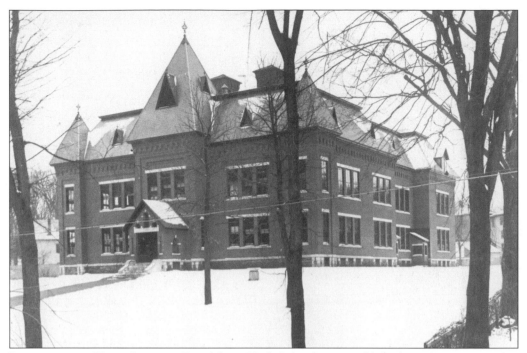

BRATTLEBORO HIGH SCHOOL. Brattleboro High School was established in 1831 in a wooden structure that was replaced by a brick building in 1883. Parts of the old wooden building were used in a house on Grove Street. There was a small wooden annex on the south side that served for orchestra and band activities. For years, each graduating class planted ivy at designated locations around the foundation of the building. In 1951, a new high school was completed at the south end of town, next to the athletic fields, and the Main Street facility was vacated. Over the next few years, the building was remodeled and the town offices were moved there. The Brattleboro Historical Society secured one of the classrooms and restored it to its original style with a tin ceiling and a wooden floor. This room continues to be the society's main office. Although the ivy is gone, the class dates are still visible around the building.

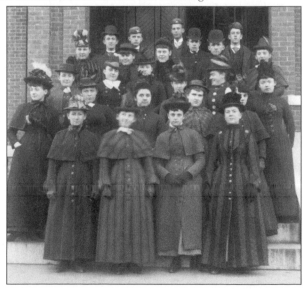

THE CLASS OF 1890. The Class of 1890 poses on the front steps of the high school. With the exception of one individual, all of the subjects seem to be attentive to the photographer.

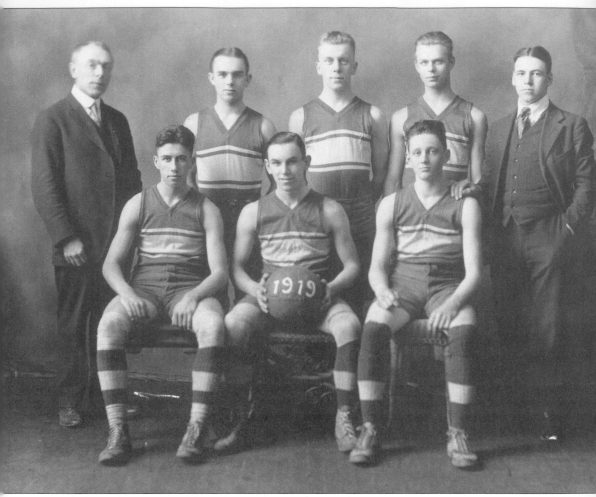

A Basketball Team. The first year basketball was considered a major sport at the high school was 1919. At the left in the photograph is Coach Stolte. Other identified players are team captain Harry Plumb, holding the basketball, and Ernest Gibson, front right. Games were played in the Armory, now the Senior Center and Recreation Center.

Seven

WISH YOU WERE HERE

I'm quite at home at

Brattleboro, Vt.

So don't expect me back.

YOU ARE THE FAIREST FLOWER OF THEM ALL

LEAVING HOME.

I am in Brattleboro having the time of my life while you are up there still as a mouse I suppose but I don't see how you can do it. I just got home from an opera with a friend whom I got acquainted with.

Well I will close hoping that this will find you getting on with Mr. Charles Stefosses, Friend Charlie. I hope you have gotten over the greater part of your sufferings. There is quite a difference between you and I . . .

I remain your friend Gertrude

POSTMARKED 1911.

Dear Papa & Mama,

How be you feeling now days. It snowed up here so we went sliding Thursday. We have got through making cider it is to cold. Uncle Fay has been deer hunting he chased one but didint get it.

XXX

Orvilla

VIEW LOOKING WEST FROM MOUNT WANTASTIQUET, BRATTLEBORO, VERMONT, POSTMARKED 1941.

Do you have any scenery like this down there? Wife of Gov. of Vt. told us at conference that she had visited Ft. Bragg and how fine it was.

Sincerely,

B.G. Crowell

96

POSTMARKED 1956.

I am on my 3rd week with same patient. Hope for 2 wks more anyway. Are the Kellys on their vacation?

I buy a sandwich every day at the coffee shop for my supper. It has been cold & rainy for past few days. Like it better than so hot. This pen is N.G.

Love, Mil

PS Do you like your bag you bought here?

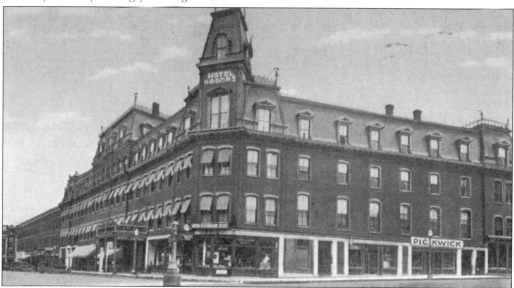

THE HOTEL BROOKS AND THE PICKWICK COFFEE SHOP, BRATTLEBORO, VERMONT, POSTMARKED 1936.

Just had nice dinner here. Proprietor gave each of us a card all stamped! Shall be thinking of you being in these "here parts".

Love to all,

J

POSTMARKED 1913.

This place is in Brattleboro. How are the hens getting along this winter, have they all got to laying yet? I went to a dance last Thur. night. I had a great old time. I expect to play for one this week, wish you were up here to play with me. We would make them spin. Expect Nelson has to work harder now parcel post has been added.

George

ON THE WEST RIVER ROAD, BRATTLEBORO, VERMONT, POSTMARKED 1944.

Dear Sister Eva,

Just a few lines to let you no I am thinking of you. I play ten games of Flinch this evening only beat two of them. It rather late now.

Love from Sister GEB

POSTMARKED 1912.

Dear Elsie:

I have had an awful sore throat. The rest is pretty bad. How are you and the rest? Can't write much this time. We are sugaring now. My address is Bernardston, Mass.

Write soon,
Amy

POSTMARKED 1914.

My dear daddy:

How are you getting along with the haying? I want to write you a letter. I'm having a fine time and hope you are. I received a card from Mary J. Turner. Ola is going to get me a pair of overalls.

From silly Lew

A Quarter Mile to Go.
Only a quarter of a mile to Brattleboro, the dapper gentleman may be waiting for the trolley to take him to the Valley Fair.

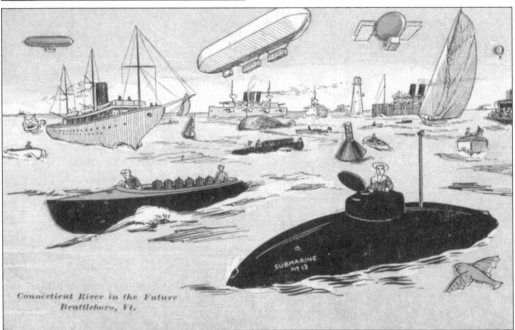

The Connecticut River of the Future. The Connecticut River has yet to reach the stage of this artist's imagination. Although there are numerous motorboats, canoes, kayaks, and the *Belle of Brattleboro* plying the waters, bona fide submarines and large vessels have yet to be seen.

Eight

DISASTERS

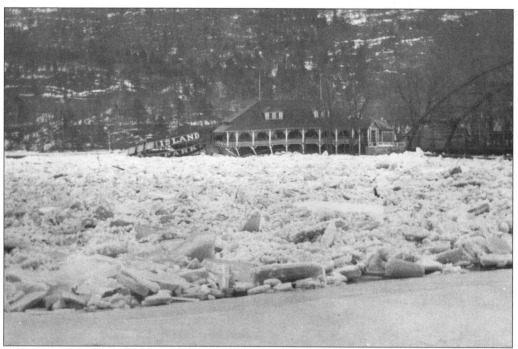

THE ISLAND PARK PAVILION. A mainstay of Island Park, the pavilion was repeatedly bombarded by ice jams and floods. Previously repaired several times by owners George Fox and Michael Moran, the February 1915 ice flood destroyed the north wing of the grandstand, demolished piers, and warped the dance floor. Partially repaired for the following summer's activities, the 1915 damage signaled the end of an era. The park continued to limp along with reduced numbers of activities. This continued until the catastrophic flood of November 1927 finished the activities at the park. The island itself almost disappeared in the flood of 1936. Between floods, ice jams, and the building of dams, the original acreage has been reduced to practically nothing.

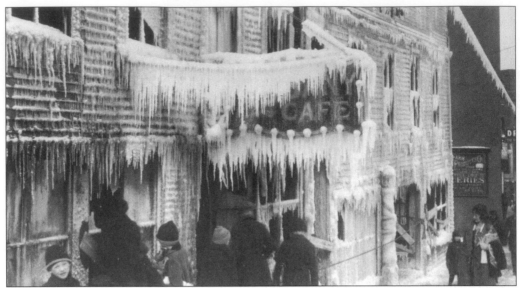

THE VINTON FIRE. Vinton's Paper Mill was the successor to the first paper mill in Brattleboro and stood on the south side of Whetstone Brook across from South Main Street. The site is now occupied by the Plaza Shopping Center parking lot. This fire in February 1922 destroyed the building and left three families homeless. Temperatures as low as 13 degrees below zero hampered efforts of firefighters and caused much suffering on the part of the men. In April, the Vinton estate proposed selling to the town a strip of land at the junction of Main and Canal Street so that the street could be widened and improved. An article to that effect was inserted in the town meeting warrant of that year.

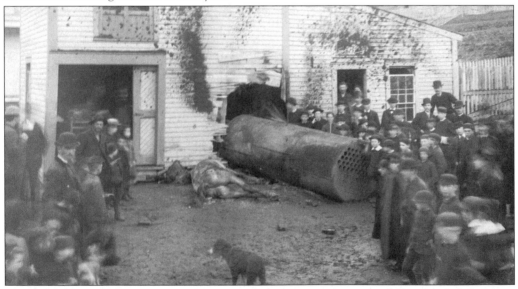

THE J.A. CHURCH EXPLOSION. A crowd gathers to view the remains of a horse killed by a boiler that traveled 260 feet through the air after exploding in 1886. Located in the J.A. Church woodworking and gristmill on Frost Street (later Holden and Martin's woodworking shop), the exploding boiler demolished the engine house of the mill, arched over a two-story building, and then ricocheted, landing in the side of a barn and killing the horse that was hitched outside.

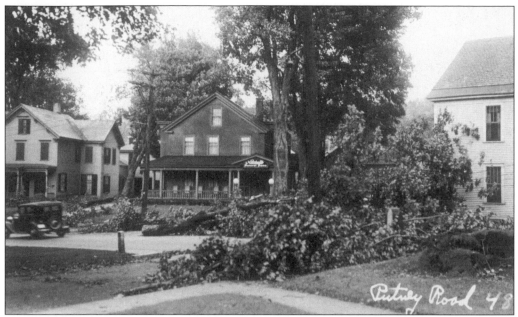

Putney Road 48

THE 1938 HURRICANE. The hurricane of September 21, 1938, with its high winds and torrential rains, brought extensive destruction throughout town. Trees were toppled on most every street, as can be seen in the photographs of the former Mitchell Funeral Home on Putney Road, above, and of the former high school on Main Street, below. Miraculously, considering the severity of nature's wrath, no one was killed or seriously injured. The Whetstone Brook, infamous for flooding, surged over its banks and inundated Flat, Elm, Frost, and Williams Streets and part of West Brattleboro. Although activity in town resumed within two days, the railroad was delayed a full week because of damage to the south as the hurricane swept through New England.

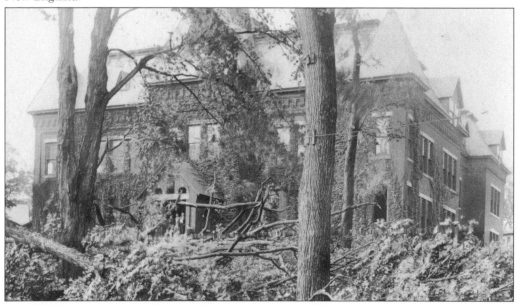

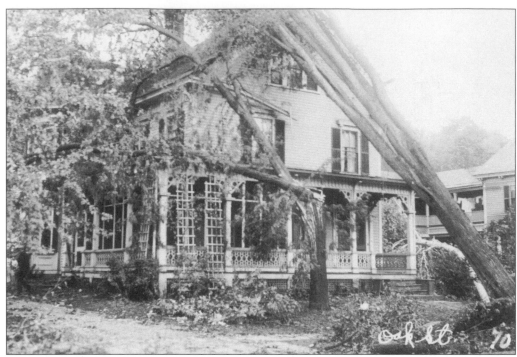

LEANING TREES. The hurricane of September 21, 1938, sent trees and limbs crashing into the Oak Street home of U.S. Sen. Ernest W. Gibson.

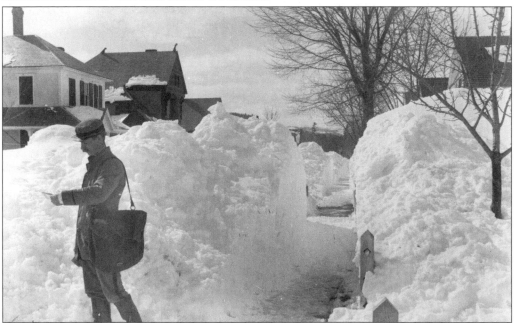

THE BLIZZARD OF 1888. In March 1888, 40 inches of snow fell in a two-day period. Drifts were 12 to 15 feet high and clearing the streets was a difficult operation. The first path was made by a team of oxen dragging a heavy chain after which horses could follow. A crew of 20 men was formed on Washington Street to dig a passage to South Main Street. No matter what the weather, Spencer Knight went about his appointed rounds delivering the mail.

THE PARAMOUNT THEATER FIRE. The Paramount Theater opened in 1937 with *High, Wide, and Handsome,* staring Irene Dunne and Randolph Scott, and closed on April 30, 1991, with a spectacular fire that destroyed the Art Deco building. The building was not always a movie theater. The original brick building, hidden for 54 years behind red enamel panels and neon signs, was built *c.* 1850. The ruins were purchased by a local architect Leo Berman and totally renovated into office and store space. The outer siding was removed to expose locally quarried granite blocks.

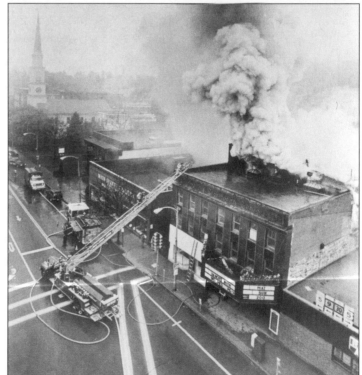

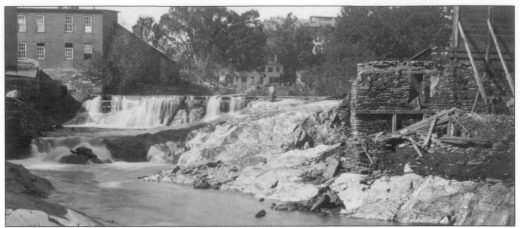

THE WHETSTONE FLOOD OF 1869. The aftermath of the Whetstone Brook flood of 1869 is obvious in the photograph of lower Main Street, minus its bridge. A 36-hour rainstorm caused the brook to rise rapidly. All the bridges along the brook were washed away between the downtown railroad bridge and the West Brattleboro covered bridge. The brook current was so strong, it swept across the Connecticut River, striking the eastern bank and weakening the bridge abutment. Employees of businesses along the brook tried to remove goods and equipment ahead of the rising waters. Horses had to be rescued from John L. Ray's livery. Workmen in Hall's blacksmith shop were nearly trapped and had to evacuate through a back door and climb a wall to Elliot Street. Families had to be rescued from Frost Street homes, including that of Mr. Frost, the house visible in the center background of the photograph. Adolph Friederich and Kittie Barrett perished in the flood.

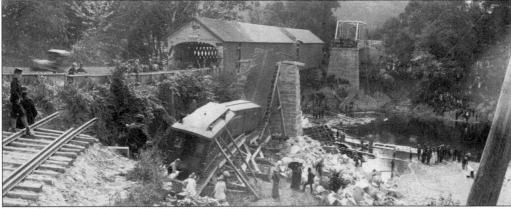

THE WEST RIVER RAILROAD WRECK, 1886. The Brattleboro community was rudely shocked by the railroad disaster of August 1886, when the Brattleboro and Whitehall Railroad Bridge across the West River went down under the 4:30 p.m. train. The bridge, the locomotive, the freight cars, and the passenger car toppled in a mass to the river bottom, 40 feet below. H.A. Smith, the engineer, went down with his machine and was killed instantly. J.J. Green, station agent of Newfane, had been riding in the baggage compartment and died later in the evening from internal injuries. The rest of the train crew were able to escape unhurt. Six passengers were injured; five escaped without harm. There was much speculation as to whether the train was overweight. Mr. Boller, the designer, reputed that while the bridge would stand the strain, he would not recommend it ". . . for nothing more that what it was designed for." Eventually, the theory brought forward was that the train had consistently been overweight and, at the time of the accident, a piece of imperfect, or cold-shot, iron gave way and contributed to the disaster.

106

Nine

RESIDENTS AND VISITORS

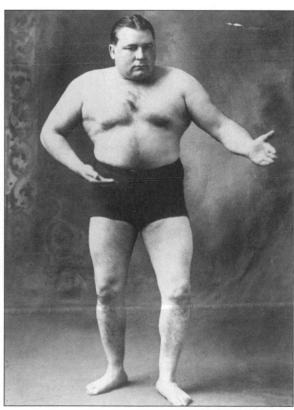

'FARMER' BAILEY. George Washington "Farmer" Bailey was a florist, a wrestler, a strongman, and a hypnotist. Born in Cavendish in 1882, he was also known as the "Brattleboro Behemoth." He was a prosperous florist who wrestled for the sport of it. In 1923, he held the New England heavyweight wrestling title. During his life, he performed as a strongman and a hypnotist in touring circuses. Bailey died in 1950 at the age of 68.

MARY CABOT. A member of one of Brattleboro's most prominent families, Mary R. Cabot is best remembered as the author of *Annals of Brattleboro*, a two-volume history that she compiled and edited in 1921.

ROBERT GORDON HARDIE. One of America's foremost portrait artists, Robert Gordon Hardie, was born in Brattleboro on March 29, 1854. He completed high school in Brattleboro before leaving for New York City, where he studied at the Cooper Institute, the Academy of Design, and the Art Students' League. Then, acting on the advice of his mentor, Professor Charlier, he went to Paris to continue his studies under the great French teachers at the Ecole des Beaux-arts. In the National Academy of 1888, his full-length, life-size, portrait of David Dudley Field, painted for the Court of Appeals at Albany, New York, attracted an uncommon degree of attention. The portrait of James H. Beal, president of the Second National Bank, served to introduce the artist to the public of Boston at the time.

GEORGE H. CLAPP. George H. Clapp, merchant and photographer, was born on April 20, 1846, and lived in town until he died in September 1938. For half a century, he was in the book and stationery business with several partners. One of his stores fell victim to the 1869 fire that destroyed the west side of Main Street. Undaunted, he moved across the street until the Crosby Block was completed. Clapp was active in the Centre Congregational Church and served as a deacon beginning in 1896. With the establishment of the YMCA in 1867, he served as the organization's vice-president for a number of years. His father, Asahel Clapp, built the brick house to the south of Centre Church that was one of the last residences to be torn down on Main Street. Its demolition provided space for the church to expand its facilities.

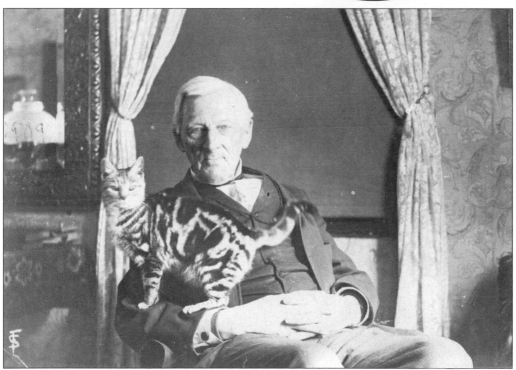

WILLIAM S. NEWTON, ESQ. William S. Newton served as Brattleboro's town clerk from 1863 to 1911, one of the longest tenures of a town clerk position in New England. He was also appointed justice of the peace in 1863. Town clerks were responsible for a variety of duties, from making holes with a punch in the ears or skins of animals, in order that the man who killed the animal might receive the bounty, to choosing the right phraseology for official documents. As a justice, he presided over the trial of Rudyard Kipling against his brother-in-law Beatty S. Balestier.

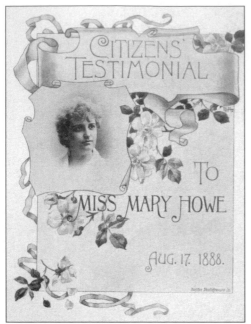

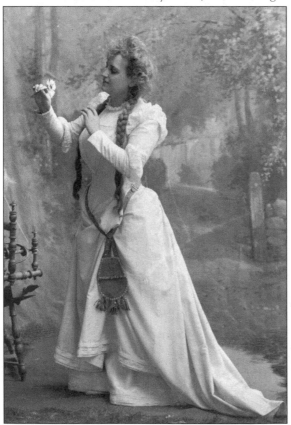

PROGRAMME

PART FIRST.

OVERTURE—La Gazza Ladra. - - - - - *Rossini*
ORCHESTRA.

SONG—"Ah, dost Thou Love?" - - - - - *Bohm*
MR. W. H. BIGELOW.

ARIA—"Ah, mio Fernando." - - - - - *Donizetti*
MRS. E. R. PRATT.

ARIA—Con Variazioni. - - - - - - *Proch*
MISS MARY HOWE.

SONG—"My Dearest Heart." - - - - - *Sullivan*
MRS. E. ALINE OSGOOD-DEXTER.

A TESTIMONIAL TO MARY HOWE. Shown are pages 1 and 2 of the "programme" for the Citizens' Testimonial to Mary Howe, held on August 17, 1888.

MARY HOWE. Following a successful season on the operatic stage in Germany, Mary Howe returned to her hometown to make her American debut in the summer of 1888. She was the daughter of C.L. Howe, local photographer, and part of a musical family. Her older brother Lucien Howe, a composer of creditable works for piano and organ, directed her early musical education and was her accompanist. Later, she studied in Paris and in Italy. Her coloratura voice was received enthusiastically by German audiences. Her favorite roles were Traviata and Rosine in the *Barbier da Sevilla*. She retired from the stage in 1905, after her marriage to Edward Burton of Massachusetts, but she continued to sing in churches and to give concerts for charitable causes. She died in 1952 at the age of 85.

MADAME SHERRI. Antoinette Sherri was a New York theatrical costume designer who built a very unusual summer home in Chesterfield, New Hampshire, in the early 1930s. Her flamboyant lifestyle (she was driven down Brattleboro's Main Street in a 1927 Packard touring car), her coquettish manner, and an entourage of good-looking young theatrical people created quite a stir in town.

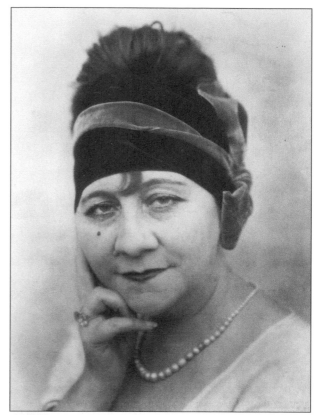

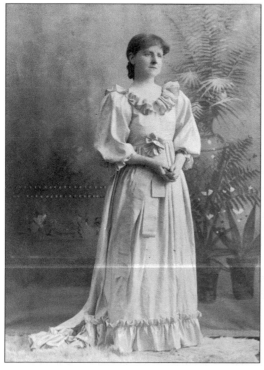

MARY WILKINS FREEMAN. Mary Wilkins Freeman, noted "authoress," became a resident as a young child when her family relocated from Randolph, Massachusetts. She was educated at Mount Holyoke College. She began writing verses and short stories at an early age. Her first published book, *A Humble Romance*, appeared in 1886. In 1887, she wrote *A New England Nun*. She eventually wrote some 25 books, in addition to numerous short stories and magazine articles. In 1902, she married Dr. Charles Freeman, but the marriage did not last. She returned to Brattleboro occasionally to renew old acquaintances, and, at the time of her death, owned a half interest in the White and Freeman block on Main Street.

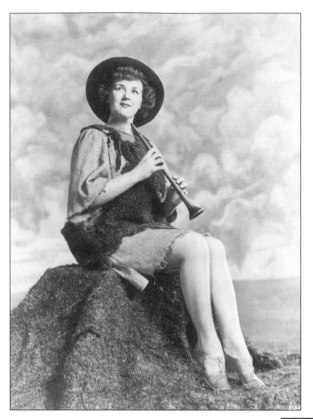

MAXINE STELLMAN. Born in West Brattleboro in 1906, Maxine Stellman graduated from Brattleboro High School in 1923 and started her singing career in the choir of the First Congregational Church. She studied music in New York and graduated from the Institute of Musical Art of Juilliard School. She was the winner of the Metropolitan's Opera Auditions of the Air in 1937. She made her Met debut in *Orfeo e Euridice*. Her career with the opera house lasted 15 years and included parts in 30 different operas. While on tour in Boston in 1942, she was called upon to assume the role of Elsa in *Lohengrin* and was given a great ovation. She returned to Brattleboro after her retirement and coached individual students. She married Joseph Caruso in 1933; they restored the house on Western Avenue that is considered the oldest in town. She died in 1972 and was buried in Meetinghouse Hill Cemetery.

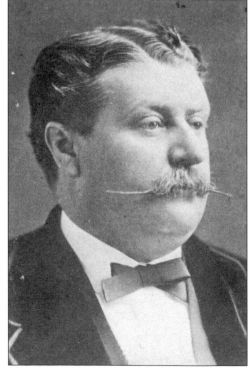

'JUBILEE JIM' FISK. James "Jubilee Jim" Fisk Jr. was born in Pownal on April 1, 1835, and was fatally shot by Edward Stokes on January 7, 1872. The murder was over the affections of Josie Mansfield. Early in his career, Fisk worked with his father, who managed a hotel in Brattleboro. Later, still as a young man, he went to New York City and eventually joined Jay Gould and became director of the Erie Railroad. He also fancied himself a patron of the arts and wound up owning Pike's Opera House. His funeral was held at the Revere House, which was owned by his father and was located on the corner of Elliot and Main Streets. It was a major event in Brattleboro at the time.

THE FISK MONUMENT. This monument was erected on the grave site of James Fisk Jr. at the Prospect Hill Cemetery. Created by sculptor Larkin G. Mead, the Fisk monument has in a circle at its base four young women. Each of the women holds one of
the following: a sack of coins, railway shares, steamship holdings, and an emblem of Fisk's patronage of the theater.

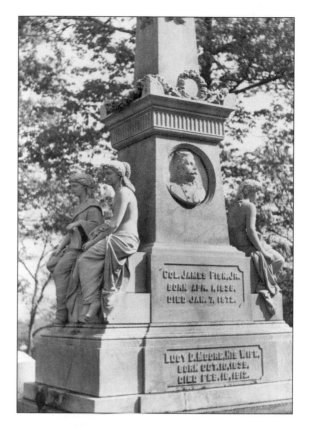

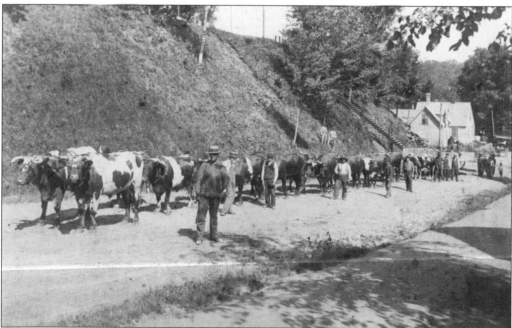

TRANSPORTING THE FISK MONUMENT. Several yoke of oxen were needed to transport sections of the Fisk monument up South Main Street to the Prospect Hill Cemetery.

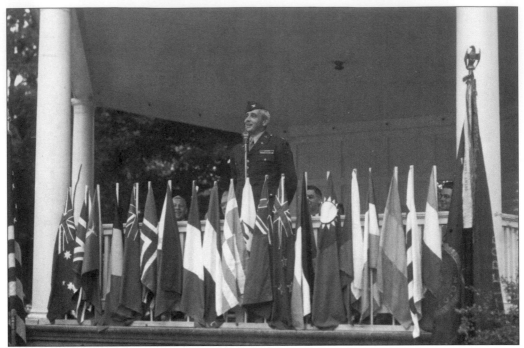

ERNEST W. GIBSON. Col. Ernest W. Gibson addressed an audience at the Brattleboro Common in August 1946. The ceremony followed a parade marking the first anniversary of V-J (Victory over Japan) Day. Gibson was a member of a prominent Brattleboro family, active in the legal profession and in Vermont politics. He was a member of the law firm of Gibson, Gibson, and Crispe; served as secretary of the Vermont Senate for a number of years; was elected governor of Vermont after World War II; served as a judge of the U.S. District Court; and also served as a U.S. senator. His sons Ernest, Robert, and David continued the family's involvement in the legal and political arenas. The new Robert H. Gibson River Garden, a lasting memorial to Gibson, will open during the winter of 2000–2001 between Main Street and the Connecticut River.

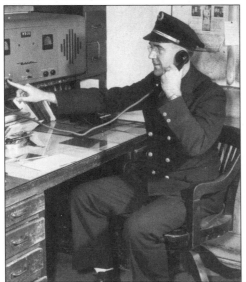

POLICE CHIEF JOSEPH HOLIDAY. Joe Holiday joined the local police department in 1938, and in 1941, was appointed chief of police. He served in this capacity until 1950, when he graduated from the FBI National Academy in Quantico, Virginia. In that same year, he was selected as a special agent. For much of his FBI career, he was assigned as the resident agent for southern Vermont. He retired in 1973. Holiday was an accomplished musician, playing trumpet, baritone, and trombone. In the 1930s, he was a member of the Vermont 172nd National Guard Band. An outstanding athlete in track, he once held the Vermont State high hurdles record. This photograph shows the chief operating a communications system, primitive by today's standards, when the police department was located in the old town hall.

A WORLD WAR II BOND DRIVE. To encourage the purchase of bonds to support the war effort, celebrities visited large and small communities across the nation. This photograph shows movie star Dorothy Lamour appealing to her audience on the Brattleboro Common to "buy war bonds."

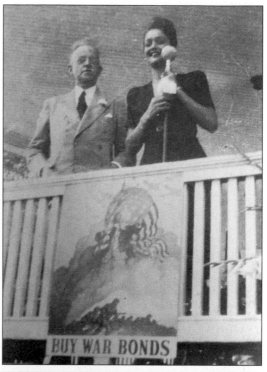

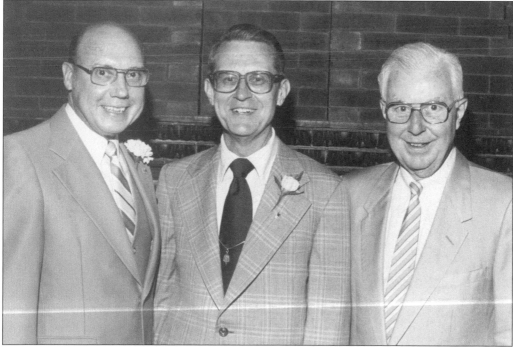

A TRIO OF BANKING MEN. Officers of the Vermont Financial Services are pictured at a meeting of the organization. Shown here, from left to right, are John Hunter Jr., president of Vermont National Bank; Alfred W. Burroughs, fiscal officer of Vermont National Bank; and James Baker, proprietor of the long-established family business, Baker's Office Supplies.

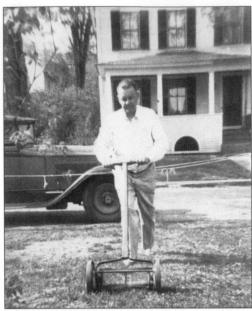

LAWN MOWING. Thor "Bab" Anderson attacks his lawn with the typical push-mower of the 1930s. Lawn mowing could be done any time of the day without disturbing his neighbors in Swedeville, a great contrast to present-day power machines.

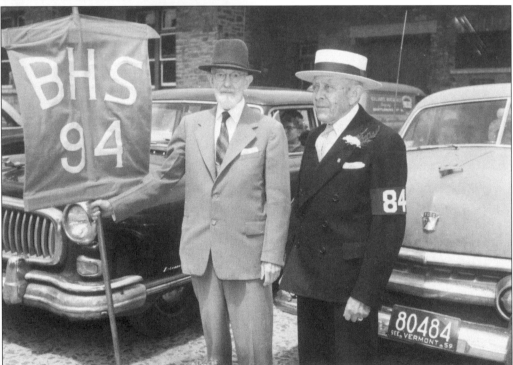

EARLY BRATTLEBORO HIGH SCHOOL ALUMNI. For years, Henry Allen, Class of 1884, and Francis Morse, Class of 1894, led the annual Brattleboro High School Alumni Parade through town. The two stalwart gentlemen are pictured in front of the railroad station in this 1959 parade. The alumni parade has changed routes since its origins in the early 1900s. In its earliest days, the line of march was from the old high school to High Street and back. The length of the route gradually increased to the present distance of approximately 1.5 miles, from the Union High School building to the Common on Park Place.

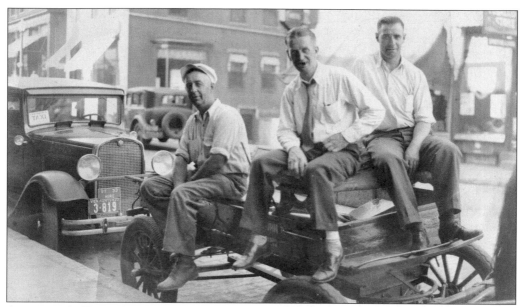

ANDERSON'S TAXI. A contrast in means of transportation is evident in the 1933 photograph of Emil Anderson, center, and two friends. Emil Anderson ran a taxi service from a stand near the Main Street bridge. In that era, taxi fares were about 25¢. The owner of this horse and wagon may have been reluctant to give up his tried-and-true transport and make the transition to the horseless carriage.

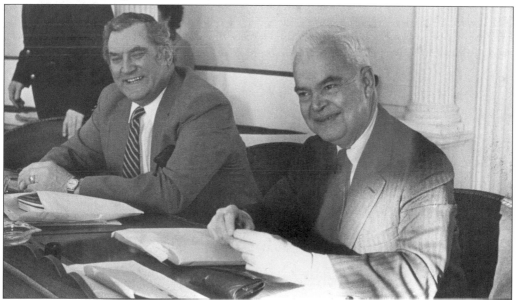

STATE SENS. GANNETT AND HUNT. Windham County Sens. Robert T. Gannett and Stuart Hunt are caught in a moment of levity in the Senate chamber at the statehouse in 1985. Gannett, a well-known Brattleboro attorney, has a long-standing involvement in town and state government, in addition to participating in many community organizations. He was one of the founding fathers of Brattleboro's unique representative form of town government. Hunt, who grew up in town and graduated from Brattleboro High School in 1945, moved to Guilford before undertaking his political career.

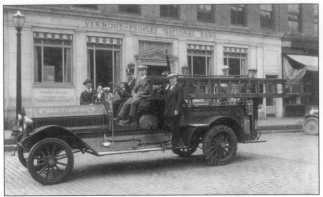
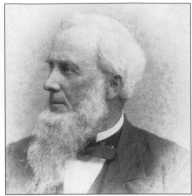

FIREFIGHTERS. Brattleboro's first motorized apparatus, left, an air-cooled, 1914 Seagrave Combination truck pauses at the corner of Main and Elliot Streets. Pictured from left to right are W. Worden, E. Huntley, A. Exner. W. Spear, H. Packard, and R. Eames. The central station was around the corner on Elliot Street, next to the Harmony Parking Lot entrance. When the station moved to a larger facility on the former Wesselhoeft Water Cure property in 1949, the old building was converted to retail space. Currently, a bookstore occupies the ground floor and the Common Ground restaurant is on the second floor.

JACOB ESTEY. Bridging two centuries, the Estey Organ Company, founded by Jacob Estey, right, provided much of the early economic growth in town. Jacob Estey was born in Hinsdale, New Hampshire, in 1814. When difficulties arose in his adoptive family, he ran away at the age of 13. After doing odd jobs for several years, he entered the plumber's trade. Returning to town in 1834, he purchased a lead and pump shop that he operated for 15 to 20 years. Sensing an increasing national interest in music in the mid-1800s, he invested in the manufacture of melodeons and the foundation of the Estey Organ Company was formed. Over the years, the company manufactured more than 400,000 organs.

JEFF BARRY. Jeff Barry, recognized as one of the most knowledgeable people on the subjects of Brattleboro photography and local history, addresses a group aboard the *Belle of Brattleboro*. On this June 28, 1998 cruise, Barry talks about the history of the Connecticut River. Seamus Kearney, the man behind Jeff, spoke later about Island Park, located between the bridges on the road to Hinsdale. The photograph on Barry's T-shirt depicts his place of employment for many years, Lewis R. Brown's photography shop.

Ten

CHURCHES

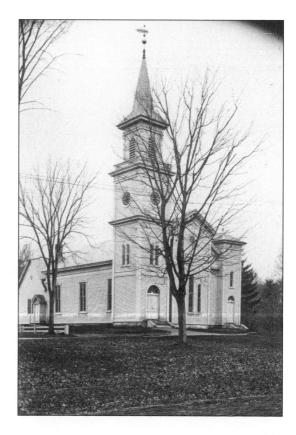

THE FIRST CONGREGATIONAL CHURCH, U.C.C., WEST BRATTLEBORO. Originally conceived in 1780 as a replacement for a more temporary structure on Meeting House Hill, Brattleboro's first church required nearly 15 years of town votes on every detail of construction before it was completed. In 1818, the building was moved across County Road, now Western Avenue, to its current location.

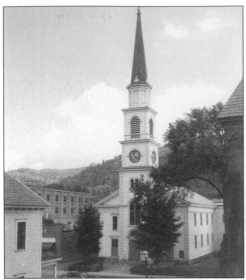
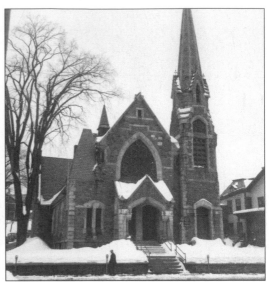

THE CHURCH ON THE COMMON, THE CENTRE CONGREGATIONAL CHURCH, U.C.C. The church on the left derived its first name when it was erected on the town common in 1816. A quarter of a century later, the building was dismantled and reassembled at its current Main Street site. At the 1843 rededication ceremony, it was called "Centre Church" for the first time. ALL SOULS UNITARIAN CHURCH. The church on the right was built on Main Street in the early 1830s, when some local Congregationalists decided to branch off and incorporate the ideas of Unitarianisim into their services. The Unitarian and Universalist churches merged in 1921. In the early 1970s, the congregation built the West Village Meetinghouse in West Brattleboro. The downtown building now is occupied by the Omega Optical Company.

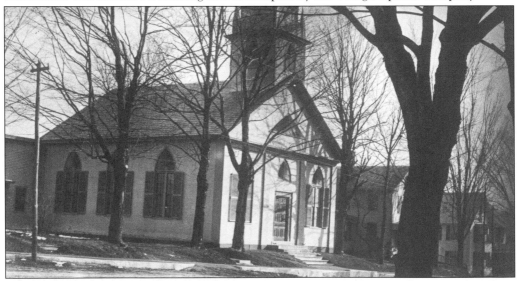

THE WEST BRATTLEBORO BAPTIST CHURCH. Built in 1834 as a meetinghouse for the West Village's Universalist Society, this brick church was purchased by Estey & Company in 1872, after Jacob Estey and his son-in-law noticed a "for sale" sign on its door. The company refurbished it and used it for religious services. In 1874, it became an officially recognized Baptist church. The building is located on Western Avenue, across the street from the Jeremiah Beal House.

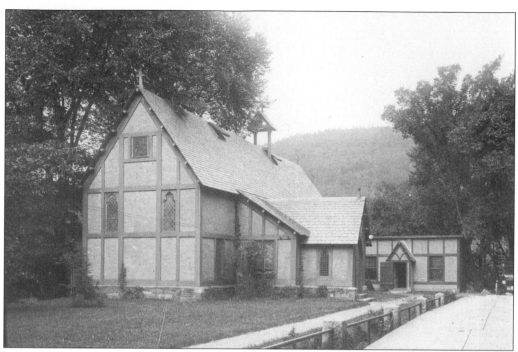

THE ST. MICHAEL'S EPISCOPAL CHURCH. St. Michael's was a "child" of Vermont's first Episcopal Church, Christ Church in Guilford. After having met in the town hall and other locations since 1832, congregants were able to attend the first services in this building in 1858. The Main Street church officially was consecrated in 1864, and in 1953, it was moved to its current Putney Road location.

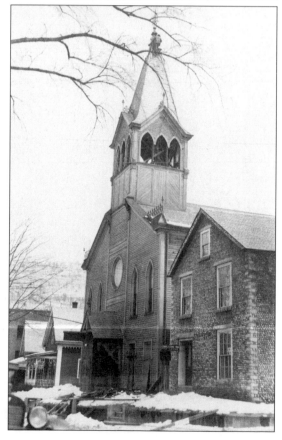

THE UNIVERSALIST CHURCH. This Canal Street church was erected in 1850 for the East Village Universalists, who had previously met at other locations, including a Methodist chapel on the corner of Clark and Canal Streets. For years the building served as the Grange Hall and, today, it is home to the Agape Church.

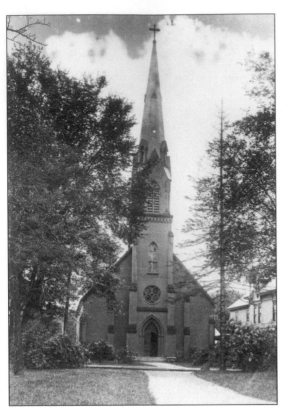

ST. MICHAEL'S ROMAN CATHOLIC CHURCH. Parishioners met in a refitted paint shop before St. Michael's Roman Catholic Church was built in 1863–1864. Eventually, a rectory, a convent, and a school were acquired for the congregation. Located on Walnut Street, the church houses an Estey organ.

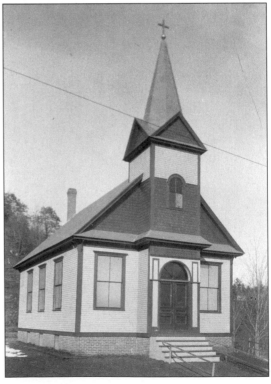

THE SWEDISH LUTHERAN CHURCH. The Swedish Lutheran Church received a charter in Brattleboro in 1893 and purchased a lot on West Street the following year. This building, dedicated in 1894, no longer stands. In 1948, it was torn down and a new church was built on Western Avenue, using materials from the old building. The congregation has been referred to as Trinity Evangelical Lutheran Church since 1939, when the Swedish language was no longer used to conduct services.

THE METHODIST CHURCH. The first house of worship for the Methodist Episcopal Church was a small chapel near the Canal Street schoolhouse, which eventually was used by a number of other denominations. Methodism lost favor in Brattleboro but eventually rallied again and built a new facility on School Street. In 1880, this church was built on Elliot Street, where it currently houses the Hotel Pharmacy. In the 1970s, the Methodist congregation moved to a modern building on Putney Road.

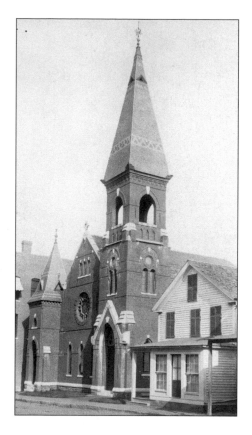

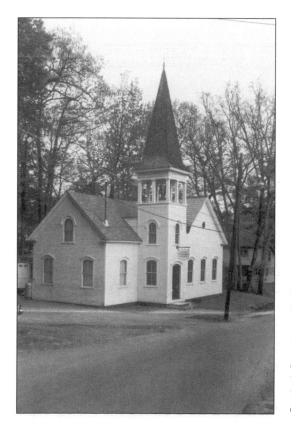

THE SWEDISH CONGREGATIONAL CHURCH, THE UNITED PENTECOSTAL CHURCH. Built on Strand Avenue in 1894, this church originally was chartered as the Swedish Evangelical Mission Church of Brattleboro, later known as the Swedish Congregational Church. For years, the United Pentecostal Church used this building, which today houses Neumann Glass Studios.

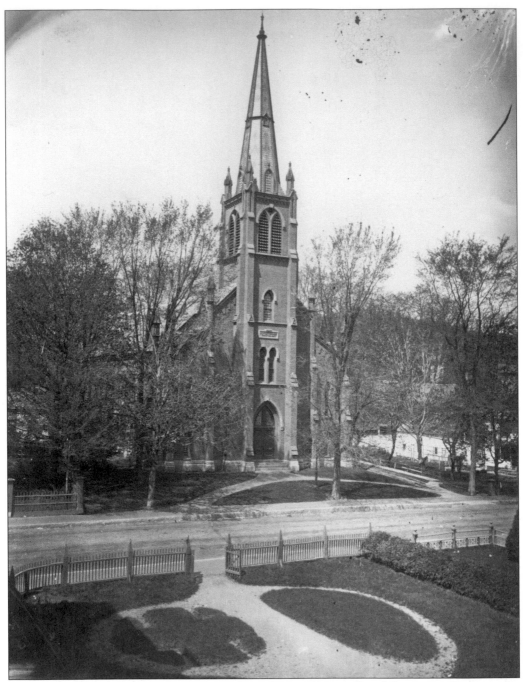

THE FIRST BAPTIST CHURCH. Some of the earliest settlers in Brattleboro were Baptists who used the Connecticut and West Rivers for baptismal ceremonies. They worshiped in various locations throughout the late 1700s and early 1800s, including the former Methodist chapel, once also used as a Millerite and Universalist meeting place. Their first church building was erected on Elliot Street in 1841 and was last used in 1868. This, their second building, was completed on Main Street in 1870. During the same time period, a second Baptist church was purchased and refurbished by the Estey family in West Brattleboro.

Eleven
EVENTS THAT HELPED SHAPE BRATTLEBORO

THE OPENING OF INTERSTATE 91. In the early 1960s, Brattleboro saw the end product of the much-talked-about interstate highway system. Interstate 91 enabled Vermont to develop its ski and tourist industries and changed the nature of Brattleboro once again.

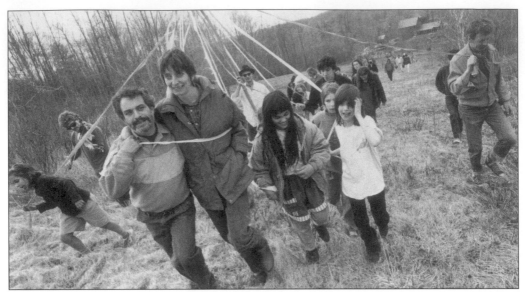

MAY DAY. Richard Wizansky and Verandah Porche celebrate May Day.

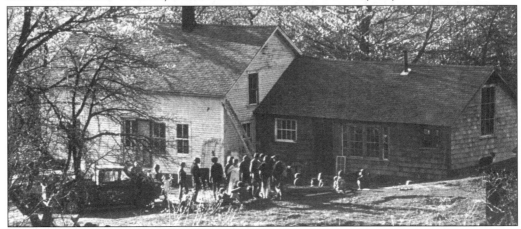

THE PACKER CORNERS FARM. Packer Corners Farms, or Total Loss Farm, was founded in Guilford in June 1968. On Memorial Day of 1968, a group of college graduates from Boston and New York gathered in Brattleboro to explore the 100 acres and the farmhouse they had heard was up for sale. Most in the group were writers. Most had been friends throughout college. All of them shared a militancy against the war in Vietnam, the spiritual and intellectual exuberance of the 1960s, a distrust of convention, a passion for adventure, and a total lack of the skills and knowledge necessary to live 12 miles out of town in a Vermont winter. They scraped together the money for a down payment, purchased the property, and set out to establish a communal farm to provide economic, dietary, political, and intellectual self-sufficiency. It worked. Throughout the late 1960s, 1970s, and into the early 1980s, Packer Corners Farm was a successful and stable commune, where the residents grew their own food, wrote books, lived simply, and blended into the Guilford-Brattleboro landscape. They sold produce and baked goods at the farmer's market. They established the Monteverdi Players, which performed at the old Brattleboro Center for the Performing Arts and on the fields and ponds of Guilford. As time progressed, a number of the residents took up work both in Guilford and Brattleboro. Many still live here, somewhat older, somewhat changed, yet still contributing to the richness, wonder, and diversity that define the town and the region.

Twelve

BRATTLEBORO TAKES THE LEAD IN ITS OWN SPECIAL WAY

ROBERT L. JOHNSON, HEAD OF OMEGA OPTICAL INC. The Omega Optical Company, with its offices in the former All Souls Church on Brattleboro's Main Street, has worked closely with NASA astronomers and engineers, designing and manufacturing a set of filters for the Hubble telescope and its accompanying Widefield Planetary camera. The filters are used to divide the ultraviolet, visible, and infrared spectrum of distant features in the universe. Omega's filters were installed during the space shuttle's mission to repair the Hubble's mirror in 1993. The Edwin Powell Hubble commemorative stamps, issued on April 10, 2000, in Greenbelt, Maryland, include five 33-cent stamp images captured by the Hubble space telescope's Widefield Planetary camera. Two of the images, including the Egg Nebula and Galaxy NGC 1316, were taken using Omega's filters. The stamps pay tribute to Edwin Powell Hubble (1889–1953), an eminent American astronomer.

THE FIRST CIVIL UNION. One of Brattleboro's strengths has been its ability to accept change. When Carolyn Conrad, and Kathleen Peterson asked Brattleboro Town Clerk Annette Cappy to open her office so that their civil union might be the first in the country, she was more than happy to accommodate the couple. On July 1, 2000, Vermont became the first state to conduct a civil union ceremony. Pictured from left to right are Kathleen Peterson, Carolyn Conrad, and Brattleboro Town Clerk Annette Cappy after completing the paper work. Again, history was made in Brattleboro.